HAUNTED
LAFAYETTE

HAUNTED LAFAYETTE

DOROTHY SALVO DAVIS AND W.C. MADDEN

Haunted America

Published by Haunted America
A Division of The History Press
Charleston, SC 29403
www.historypress.net

First published 2009
Second printing 2011

Manufactured in the United States

ISBN 978.1.59629.804.0

Library of Congress Cataloging-in-Publication Data

Madden, W. C.
Haunted Lafayette / W.C. Madden and Dorothy Davis.
p. cm.
ISBN 978-1-59629-804-0
1. Ghosts--Indiana--Lafayette--Anecdotes. 2. Ghosts--Indiana--Lafayette Region--
Anecdotes. 3. Haunted places--Indiana--Lafayette--Anecdotes. 4. Haunted places-
-Indiana--Lafayette Region--Anecdotes. 5. Lafayette (Ind.)--History--Anecdotes. 6.
Lafayette (Ind.)--Biography--Anecdotes. 7. Lafayette Region (Ind.)--History, Local--
Anecdotes. 8. Lafayette Region (Ind.)--Biography--Anecdotes. I. Davis, Dorothy. II. Title.
BF1472.U6M333 2009
133.109772'95--dc22
2009033678

CONTENTS

CONTENTS

ACKNOWLEDGEMENTS

The Monticello and Lafayette Libraries and Historical Societies receive a special thank-you for doing a wonderful job of maintaining their communities' pasts. Also, thanks to the Purdue University Archives for its information on Lafayette and West Lafayette history. These institutions are a great asset to future generations. To all those who shared their story, I thank you.

A special thank-you to W.C. "Bill" Madden, who has been a great mentor as I continue to learn from him.

For my husband Chris and our children, whose support, love and encouragement allowed me to complete this book. For my father Paolo Salvo, who first taught me the importance of hard work and ambition; by example he is a remarkable man.

In closing, I must mention Jamie Davis, whose strength and courage is an inspiration for anyone feeling afraid. Nancy Bell, I would be lost without you. Bill Bell, thank you for answering all my questions about days gone by. To Rose Mattos, who is the most real and genuine person I have ever met. Patt Ottingerand and Misha Bergen are my kindred spirits; I'm so grateful to know you.

All those mentioned above have had a positive effect on my life that has led me to follow my goals.

–Dorothy (Salvo) Davis

Thanks so much to the many people in Lafayette and the surrounding area for helping in researching some of the ghost stories, legends and other creepy stories. Thanks to the storytellers in the area, who led us to

ACKNOWLEDGEMENTS

some interesting stories. A special thanks to the Warren County Historical Society for its information on Mudlavia Lodge.

A special thanks to Dorothy Davis for letting me help her with this project. It was her idea.

And a special thanks to my wife, Janice, who allows me to pursue my passion—writing. And to God for giving me the talent.

<div align="right">–W.C. Madden</div>

INTRODUCTION

While Lafayette has a lot of history and a number of historical books have been written about it, this book takes a very different approach. This book will open your eyes to another aspect of Lafayette and the surrounding areas that no book has approached. It's a book about the paranormal occurrences that have been talked about but never written about until now. It's a book about ghosts and other strange happenings in this area.

Some of the stories in this book are connected to the history, such as the hangings in Lafayette, the Battle of Tippecanoe, World War II, John Purdue and others. Other stories involve some scary homes or places, like a park and a cemetery in Lafayette.

In any case, we think you'll enjoy reading about a different side of Lafayette and the surrounding area.

PART I
LAFAYETTE HAUNTS

COLUMBIA PARK ZOO

The atmosphere was perfect. Cobwebs draped over an old war cannon made of steel. The nearby outbuildings appeared dark, gloomy and musty. Plus, the day had been warm, and the fast drop in temperature had created an eerie fog. It had been a late summer night in 2004 that forever changed one woman's view of the paranormal.

Lori, a retired restaurant owner, described the moments leading to her encounter with a ghostly presence. She said that this was the first time in many years she was talking out loud about what she encountered, or rather who encountered her. She was always afraid that just voicing out loud what she had witnessed might allow the entity to reappear.

The unnerving incident happened just minutes after taking her evening walk by the water at Columbia Park Zoo. Normally, she looked forward to this part of her routine. The instant calm she felt as dusk slipped into night usually soothed her into perfect sleep when she slipped under the covers later in the night.

This particular evening wasn't to play out that way. Lori could not pinpoint anything different about the sound of the night around her. She only remembers getting a prickling sensation on the back of her neck as the air around her seemed to get even colder than it had been a moment earlier.

Feeling dizzy and unbalanced, she dropped forward on her knees and sat on the ground trying to regain her strength. Closing her eyes and trying to ignore the growing sense of fear, she took several deep breaths. Giving herself a mental pep talk, Lori told herself that she was being childish and had nothing to fear.

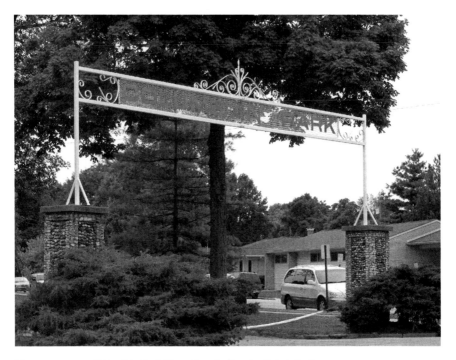

The entrance to Columbia Park Zoo. *Photo by Dorothy (Salvo) Davis.*

Fighting the desire to stay as she was kneeling down with her eyes tightly shut, Lori found the courage to open her eyes.

She opened her eyes and stood quickly, willing her legs to find the strength to run. A man was right in front of her! A tall man, a shadowy figure, couldn't have been more than five feet from where she stood frozen. Not really seeing him but the outline of his shadow, she couldn't tell much about his appearance.

Unable to find her voice and scream, she leapt into action running in the opposite direction from where the man had stood. Gasping and running out of breath, she ran until she reached the edge of the playground. Very shaken and more afraid than she ever had been, she attempted to reason in her mind what she had just seen. Lori tried telling herself that she likely just saw the shadow of another park stroller and had no doubt looked very foolish running as she had.

At this point, she was seconds away from becoming hysterical. Determined to head home with haste, she was just starting to walk when she felt a tap on her shoulder. Halting her step and knowing she shouldn't turn around, she froze. Shaking and frustrated, she was still unable to find her voice. Wanting desperately to ask who was behind her, tears began to fill her eyes. The fear had made her mute!

Again there was a firm tap on her right shoulder. It felt as if ice had just slid down her back. To this day Lori still is not sure how she even managed it, but she turned around and faced the source of her most fearful night.

Before Lori stood a man in solid form, but in her words, "He was hazy." The man was tall and had a 1920s or 1930s look about him. He wore some kind of uniform with white pants and a white button-front shirt with stripes across the front. His presence was overpowering. Lori felt as if the clocks had stopped. The man seemed to be struggling for her to hear his words. Although his mouth was moving, she heard not a sound, but rather just felt a feeling words cannot describe. At best, she was stunned and feeling grave fear.

The next thing Lori remembers is waking up and finding herself lying on the moist ground. Thinking she must have fainted from fear, she ran for home faster than she had as a young girl without looking in any direction.

To this day, Lori is fearful of going back to Columbia Park Zoo.

HAUNTED HOUSES

Rainy Brook Subdivision

How does a haunted house look? Should it be an old, time-worn structure with shutters barely hanging on to the hinges and a weathered roof with a sinking front porch? Is that the kind of place a ghost is likely to dwell? What if the house is brand new with fresh paint, sparkling floors and not one creaking door or step?

In truth, ghosts are reported in all kinds of structures all the time. In theory, it's not an atmosphere that would seem to attract a ghost, but

the history of the home or location. A haunting could even result from current activity or emotions. We're never safe from the paranormal simply because a structure is new.

Just ask Anita G., who found herself living in a new home plagued with haunting disturbances that rival anything seen in a 150-year-old Gothic Victorian mansion. This is Anita's story.

After working more than twenty years as a nurse and saving every dime, she and her husband Ralph finally saved enough to have their dream house. The home was built to accommodate their large family of six. Anita and Ralph both had children from previous marriages and two together. The home was sprawling and modern. The large home was very inviting, with curb appeal that hid what lurked within from visitors as they approached the front door.

Their home was built in Lafayette and located in the subdivision of Rainy Brook. With granite counters, high ceilings and lots of built-in bookcases and shelves, the couple had thought this would be their home for years to come. Anita envisioned many holidays shared in her spacious new dining room. She should have known better from the start.

When the home was close to completion, an electrician was working one afternoon on some lighting in the dining room. He went to the fuse box first to turn off all power in the dining room. He climbed the step ladder and went to work on the light when he was immediately zapped by an electrical current, which landed him hard on the floor. At the time, two other contractors were working on the floor above. Both men came running when they heard the electrician scream. After making certain that he was okay, the contractors asked him how he could have forgotten to flip off the circuit breaker for the room. The electrician, knowing that he *did* turn the fuse off, went to check the box first thing, with the other contractors following on his heels. To their surprise, not only was the box wide open, but the breaker was also back on! A few other contractors assigned to work on the property also had strange stories to tell. Needless to say, it was a relief to many when this project was completed.

Lafayette Haunts

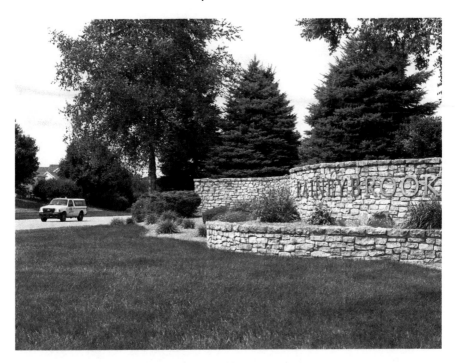

Rainy Brook subdivision is the site for a new haunted house. *Photo by Dorothy (Salvo) Davis.*

Not long after moving in, Anita's sixteen-year-old daughter, Ally, started complaining about feeling as if someone was watching her in her bedroom at night. Her bedroom was upstairs, far from the downstairs master bedroom, a choice that had been perfect due to the fact that the couple also had a new baby daughter who did not always sleep all through the night.

At first, Ally felt that it was the fear of being in a new house. She did have a room to herself during the week when her eighteen-year-old sister, Ronny, was at college. At first, strange things would happen only when she was alone in her room.

On the second night in the house, Ally awoke to the feeling of someone else in the room. Although she saw no one, the feeling didn't go away. About two weeks after moving in, her closet door began to open on its own! The first time Ally saw the door open, she was sitting at the desk across the room. The door popped open by itself, so she closed it, thinking

that she must not have had it closed all the way. She sat down knowing that she had closed the door all the way. A moment later, her studies were interrupted by a sound that caused her to look in the direction of the door just in time to see the handle move and the door pop open. On shaky legs, she ran from the room, not bothering to close the closet door.

Downstairs, her mother was preparing dinner, so Ally shared the strange event. Anita assured her that her doorknob may need adjusting and didn't latch correctly. Believing that the pressure from the incorrect lock caused the door to open, Anita assured her she had nothing to fear.

That evening, Ally curled up under the covers. She again felt the presence of someone in her room watching her. Repeating her mother's words in her head from earlier that afternoon, she finally fell asleep but still was not convinced that she had nothing to be afraid of.

Although it didn't give Ally any relief, a few months after moving other family members began to experience strange occurrences in the house. Doors would open or slam shut on their own, and lights and televisions would switch on and off by themselves. Things would appear to have been moved, and the coffee pot would start brewing coffee when it was not on a timer.

On a Friday evening, Ronny had come home for the weekend from college and was alone in the house. She put her things in the room and headed directly for the kitchen. As she was raiding the refrigerator, the television in the family room came on. She called out from the kitchen, "Is anyone home?"

When no response came, she headed to the family room. Nobody was there. She turned off the television and looked out the window at the driveway. No one had arrived home since she had been there.

Back in the kitchen, she started making herself a sandwich when the microwave suddenly started. Startled, Ronny walked over and looked at the empty microwave and turned it off. Thinking it odd that it came on its own, she began to feel uneasy. She felt as if she was being watched. Ronny ate her sandwich quickly. Once finished, she walked over to the sink to wash her dish. She reached out to turn on the water and froze. The faucet turned on full blast before she even touched it! She'd had enough. Grabbing her keys, she ran from the house.

Lafayette Haunts

The next few weekends she opted to stay at her dorm house instead of coming home. This created many arguments with her stepfather, who just didn't believe her reasons for being afraid of the new home.

Anita's husband, Ralph, never seemed present for any of these activities. Ralph always had a logical explanation for the occurrences. They were caused by drafts from the heating and cooling units or power surges he'd say. Those logical explanations eased their minds and life went on—although odd things continued to happen.

One night, a year after moving in, Anita and Ralph enjoyed a night out with friends. When the small group returned to the home for coffee and dessert, the mood was good.

While they were all sitting around the table chatting, they heard a noise from Ally's room upstairs that sounded strangely like someone coughing. All conversation stopped immediately; everyone had heard the noise. Anita called out to Ally but was reminded by the rest of the group that her car hadn't been in the driveway. She wasn't home and the younger children were at Anita's parents' house. Anita ending up joking that it was just "our ghost," and the visit continued. The mood no longer seemed as positive, and the guests left early after making up excuses.

Afterward, Ralph and Anita went upstairs to try and discover what had made the sound. Ralph grabbed an umbrella as a weapon, but Anita knew that there was no stranger in their home. She knew something that he had never been able to accept—the home was haunted. The search, as Anita expected, turned up nothing. Downstairs again, Ralph helped her carry coffee mugs to the kitchen. When he entered ahead of her, she heard a crash. Ralph had dropped the mugs and stood in shock. Every cabinet in the kitchen was open, and the water was running at full force. After the shock wore off, Anita swept up the broken glass, thinking that at the very least her husband finally experienced what everyone else had for months.

The strange events have never stopped. The family no longer lives in the home. Anita wasn't surprised when the new owners called shortly after moving in asking if they had ever had problems with the water pressure. They claimed the water kept coming on by itself.

Main Street

Several years ago, Jessica was finishing up graduate school at Purdue University. Thinking that it was her good fortune, she was invited to split the rent three ways in a beautiful old Victorian home on Main Street in Lafayette. The home had been split into two apartments directly across the street from a fire station. Despite the renovations that turned the home into apartments, the home still held historical charm.

A week after moving in, Jessica began to feel exhausted. She found that she was unable to sleep at night. She had an eerie feeling of someone standing and watching her from the doorway of her room, which kept her awake at nights. Knowing that she must adjust to the home, she told herself that the creepy feelings and odd noises were probably natural when living in an old home. Yet Jessica just couldn't shake the feeling of loss and despair that consumed her since moving in. Oddly, her two roommates, Carl and Sandy, never heard a thing. Graduate students also, they were newlyweds working toward a future and life together.

One winter night, Jessica came home late. She was tired from a long evening of studying with friends. Entering into her room, she threw her book bag on the bed. She was startled to hear a moan come from the bed. She froze. Jessica looked down and saw the form of someone cuddled under the blanket. Thinking that Sandy had an argument with her husband, she gave her friend a shake. "Wake up, Sandy," she told her.

Getting no response, Jessica turned to go to the kitchen for a drink. As she walked out into the hallway, her attention was drawn to the sound of someone coming in. She stared in disbelief as her roommates greeted her.

"We went to the game and the Boilermakers won," said Sandy.

"Yeah, you missed a really good game," added Carl.

The couple then noticed how pale Jessica had become. "I thought you were in my bed, Sandy," Jessica explained.

Carl immediately went to her room. A minute later, he returned. "I didn't see anyone up there," he said.

Sitting her down, the couple explained to her that their last roommate moved without any notice. She was also a Purdue student and claimed to often feel afraid in her room.

"Why didn't you tell me this before?" Jessica asked.

"We didn't think it would help to tell you," admitted Carl.

"We didn't want to scare you," added Sandy.

Feeling frustrated and alone in her experiences, Jessica began to ask her neighbors if they had ever heard anything strange about the property. Lucky for her, the previous owner of a nearby home was visiting some friends when Jessica ran into them outside.

During the conversation, Jessica asked her about the home she resided in and who use to live there. The woman got quiet for a moment and then shared with her a sad story. "Years ago, a family lived in the home with their two sons," she explained. "One of the sons lost his girlfriend in a car accident and was never the same. He began to drink and use drugs. His family seemed unable to pull him from his grief. Isolating himself, he spent all his time in his room. One morning, his mother found him in bed cuddled under the covers. She tried for several minutes to wake him. Pulling the covers from her son, she found his lifeless body. He had overdosed during the night, but many felt he died of a broken heart for his lost love."

"Oh, my God!" Jessica exclaimed.

Financially, the apartment made sense, but her sanity was more important to her, as well as her dreams for a successful future. So, Jessica moved out the next weekend and moved in with her cousin. Within a few weeks, her spirits rose and joy seemed present once again in her life.

Main Street Near Ferry Street

The adage "When it rains it pours" proved true for one young couple and their two-year-old daughter. The religious family always tried to remain optimistic when looking to the future but fell on hard times, and a frightening experience made things even worse.

Bill and Kate Roth found themselves with no alternative but to move their family into Kate's parents' home, which was in a nice and tidy community located in the heart of Lafayette, close to all that the city has to offer. With natural colors and well-kept curb appeal, this was a great place for a family starting over.

Kate's parents spent six months of the year in south Florida. Her parents had just left for Florida, leaving their home trusted to the couple and knowing that this gave Kate and Bill a sense of independence and a timed goal to once again stand on their own two feet. Things started to take shape when, shortly after moving in, the couple both got nearby jobs and found a great daycare for their daughter, Sarah. Everything was working out just as they had hoped—well, almost everything.

Kate's new job required her to leave home every morning by 6:00 a.m. to allow enough time for her to drop Sarah off at daycare and get to work by 6:30 a.m., which is not what bothered Kate. She didn't mind the early start to the day; it was the lack of sleep that was catching up with her. Their daughter wouldn't sleep in her room—period! Kate was certain that it wasn't that Sarah wanted to be in her parents' bed; she just didn't want to be in her own room.

Even when Kate got her to sleep in another part of the home and move her back to her own bed, Sarah would wake soon after with terrifying screams. Sometimes, if Sarah had fallen asleep on the couch, her parents would leave her. She would sleep soundly all night.

The couple tried everything to solve this problem from night lights to soft music, but nothing soothed Sarah's fears. Kate even got her parent's permission to paint the room in a soft pink with bright and happy Disney princess wall décor and bedding. The room was now friendly—a room right out of a catalogue. Still this didn't resolve Sarah's night terrors. She wouldn't even play in the room. If Kate put her favorite toys in the room, Sarah would have her mom go with her to retrieve them. Finally, Kate discovered the reason for her daughter's anxiety.

A friend had suggested leaving a recorder in her daughter's room to see if she could solve the mystery. Perhaps her daughter was tossing and turning in her sleep or waking from nightmares. Not really expecting to find anything out of the usual, she placed a recorder near Sarah's bed. During the night, Sarah again woke up calling for her mother.

The next morning, Kate was stunned when she played the tape back. Noises sounding like footsteps, dragging and muffled voices would continue off and on during the night. Kate and her husband had never heard or seen anything unusual in the home. This recording freaked them out. At this point there was no denying that someone or

something was in the home with the family and that Sarah was aware of it!

The next evening, Bill decided that he would sleep in Sarah's room and have the recorder on while Sarah slept with her mother. Not long after laying down, Bill fell quickly asleep. During the night, he did wake up briefly feeling very cold. After getting another blanket off a nearby chair, he fell right back to sleep. Nothing that he was aware of had happened during the night. Sarah had slept peacefully during the night without waking in her parents' bed.

That afternoon they played the tape back. Immediately, both were stunned when they heard a light buzzing sound that started as a hum and got louder. At one point during the playback, the sound of several different voices could be heard whispering. It was not possible to make out what the voices were saying or even if they were male or female, but that it was voices Kate and Bill were hearing without a doubt.

A family friend suggested the couple burn sage, an old Native American ritual sometimes referred to as smudging. This ritual is thought to remove any bad feelings, negative thoughts, bad spirits or negative energy. It was suppose to cleanse both physically and spiritually. The couple decided to give it a try.

Kate and Sarah left for an afternoon as Bill walked through the home burning sage in every corner and saying prayers. The smell was strong, and the sage burned hot, hurting Bill's nostrils, but he continued with determination to reclaim their space. Once the cleansing was done, Kate and Sarah returned home. As soon as she entered, Kate exclaimed that the home had a strong smell of flowers. Still wanting to be sure they had ridden the home of the unwanted guests, they allowed Sarah to sleep in their bed another night while they recorded Sarah's bedroom.

That night, the couple awoke to a heavy thumping sound coming from Sarah's room. This was the first time they ever heard anything firsthand. Bill investigated but found no source to the noise. The thumping continued throughout the night and several more times over the next few months. When Bill would turn on the light, all noise would stop. The smudging seemed to have made the energy in the home stronger, as the sounds couldn't be heard with the recorder anymore.

Both Bill and Kate were relieved that the strange sounds seemed to be isolated to Sarah's bedroom. They tried putting recorders in other parts of the home and never found anything but the distant thumping and shuffling coming from Sarah's room occasionally.

The family bunked together until they were finally able to move out.

Kate's parents were Catholic and didn't believe in the paranormal. To her parents, speaking of such things was wrong. Kate did get the nerve to ask her parents once if they had ever had anything unusual happen in the subdivision. Her mother quickly replied no and changed the subject.

Before Kate and her family moved in, the room was used for storage, and when her parents returned, they again turned the room into storage. Kate always thought it was strange that her mother had her sewing supplies taking up half the living room when she had a perfectly good room for it all. No longer does she feel that way.

South Street

Looking back after thirty-four years, Andrea Douglas can say with a fair amount of certainty that the house in which she grew up in Lafayette was haunted. Creepy feelings or strange bump-in-the-night memories could easily be explained away by casting the blanket of an "overactive child's imagination" over the incident, except for a particular incident that would leave one person so terrified and brand itself forever in the memory of the unfortunate witness.

When Andrea was twelve years old, she lived in a home on a street lined with historic houses near downtown Lafayette. The home was large and spacious with a lot of historical value, but to a child it was simply a creepy old home. Andrea remembers that it was springtime, but she doesn't remember the day of the week or even what time of night when this event occurred. She does distinctly remember waking up in her bed lying flat and looking up at the ceiling.

Passing through the window was a slanted rectangle of light created by the moon. She does remember wondering what had woken her when, in the space of a breath, a desperate feeling of sick dread filled her entire body. Searching the room only with her eyes, a chill filled the air

around her. Pulling the covers higher to her chin, she turned her head to the left, and there at the side of the bed was a small, thin human head approximately six inches away from her face with its chin nearly resting on the side of the mattress.

Andrea now knew exactly what the expression "deer caught in headlights" means. The deer quits breathing and becomes still as a stone when confronted with danger. Precisely in that moment, she was the deer. Feeling her skin grow cold, for the first time in her life—up to now at least—she experienced pure terror. She lost control of her bladder, but otherwise she didn't move a muscle. She didn't blink and didn't even want to breathe.

Looking back, she remembers that the head had very pale, pasty skin with lips that were pulled up away from the very human-looking teeth, as if they were dried out. The hair was black, coarse and long with individual hairs sticking up on the top like on a person who hasn't combed their hair in a long time.

She could see the moonlight glinting off the eyes. Despite the face being somewhat in shadow, the irises were just very dark. A strange glow of mist seemed to surround the head.

After a time, which must have been only seconds, she was able to gather up enough courage to close her eyes. At this point, she just started praying over and over again in her mind, "Please go. Please go. Please go. Please go. God make it go…"

Barely a perceptible whisper of movement and cold draft went over the mattress, and with it the cold fear disappeared. Andrea opened her eyes, and it was gone. She still remembers moving to the far side of the bed and telling herself to stay awake until dawn, but she cannot say for sure whether she made it.

For a long time after her nighttime visitor, she dreaded sleeping in her bed. To her relief, she never again saw the head. Over the years that followed, she did dream of the head of the man she'd seen. He was very much alive, and it was a different time. He was sitting on a horse with a noose around his neck and about to be hanged. The scene took place right in front of the home she grew up in. Right as the horse was pulled from below him, she would wake with a feeling of sadness rather than fear. This dream recurred even after she no

longer lived in the home. To this day she has no explanation for the repeating dream.

Many years later, while telling ghost stories with some friends in her freshman year of college, a boy related the tale of seeing a thin, grey-skinned arm covered with black, wiry hair come up to the side of his bed. Andrea told her story of the head and the dream she still occasionally had. They both became convinced of one thing—who knows what is out there?

CRAZY WOMAN

More gruesome than ghostly is one of the strangest murder cases in Lafayette history. Marcia Heald, who may have been possessed, was convicted of brutally murdering a neighbor back in 1982 in a Lafayette apartment.

On August 2 of that year, Marcia attended a poetry reading at the Smiths' apartment at 601 ½ New York Street. Shelly and Marcia discussed poetry, folk music and antiques that night until after 1:00 a.m. Shelly offered her couch for Marcia to sleep on, but she declined and went to her car instead.

At 5:00 a.m. the next morning, Gerald left his wife Shelly to deliver newspapers. Some time later, Marcia awoke in her car and decided she had to return to the apartment and kill Shelly Smith because she believed her to be a serpent possessed by Satan.

Marcia first took off all of her clothing in a downstairs bathroom. She also went into the kitchen and grabbed a paring knife. Then she went into Shelly's bedroom. Shelly was lying naked under the covers. She looked like a snake to Marcia, who yelled, "Yahweh's kingdom come" and began stabbing her.

Shelly screamed with pain and ran from the bedroom toward the kitchen, but Marcia grabbed her by the hair, pulled her down and then began stabbing her repeatedly in the head, neck, chest and back. Then she tried to remove the "snake's" head, because she felt it would be rejuvenated if she didn't behead it. She sawed with a knife and part of

Lafayette Haunts

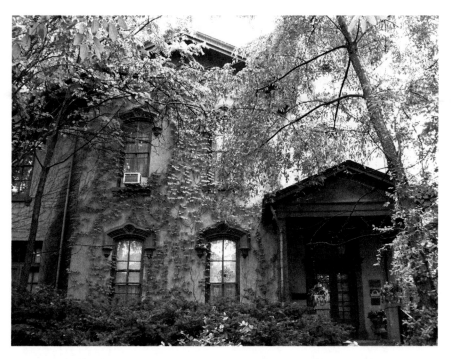

This was the historic house at 601½ New York Street in which Marcia Heald brutally murdered Shelly Smith. It's now on the National Register of Historic Places. *Photo by W.C. Madden.*

a mirror. Then she tried twisting it off. She gave up in her attempt to remove the head. She went back to the bathroom, showered, dressed and then left. She drove around for awhile and stopped and ate breakfast at a restaurant near Purdue University.

Later that day, Lafayette Police apprehended her and got a confession out of the crazed woman.

Marcia was not your typical murderer. The Plainfield resident had been a librarian at the Indiana State Library. The divorced mother of two spent two Saturdays a month at the Indianapolis Children's Museum demonstrating weaving. However, she told court psychiatrists that she was Eve from the Garden of Eden.

She pleaded innocent by reason of insanity, but the judge ruled that she was competent to stand trial.

Her attorney, Brent Westerfeld, tried to get a continuance before the trial began, because he said his client wasn't competent to stand trial.

Psychiatrists differed on whether she was insane. Two of three determined that she knew what she was doing at the time of the murder.

At the hearing, Marcia said: "It was written 2,500 years ago. It would be at Lebanon [where the trial had been moved to]. It is Yahweh's will. Human beings have no knowledge of my world. They shouldn't meddle. I am not a human being; I am an animal. I became an animal in March."

Her attorney said she could not get a fair trial with twelve human beings.

Asked who the Messiah was, she replied, "I am. My mission is…to proclaim Christ, to replace religion with Yahweh, to replace law with Yahweh, to replace sanity with Yahweh, to replace death with Yahweh." She added that she had died seven times and had been reincarnated each time. "I'll come back in my next life to finish the mission."

The judge turned down the request for a continuance, and jury selection was made immediately after the hearing. Westerfeld told the jury during his opening statement that Marcia was trying to kill a snake, not a human being.

During the trial, a coworker of hers, John Selch, testified that she had written down her strange and religious philosophical thoughts. In those writings, she believed that a fellow member—Brian Thornton, of a Lafayette group that did eighteenth-century reenactments— was Christ.

A letter was introduced during the trial that was written the day before Marcia murdered Smith. In the letter, she wrote: "This day Aug. 1 is the last day of my earthly life." That night she killed Smith.

Marcia was the first witness for the defense. She began her testimony by claiming that her name was "Mars, the God of War" and that she was 5,743 years old, but 44 years in her present form.

She later testified, "I began seeing something in front of Shelly [Smith]. I saw this face and I saw it was a snake. Yahweh [God] was sending me messages. I could see something at her neck like scissors or knives. I said to myself, 'Is this the lady I have to battle with?'"

Marcia believed Shelly to be a serpent. "You always have to cut off the head of a serpent," she said.

A jury took only four and half hours to convict the woman. The forty-four-year-old woman was sentenced to forty years for the murder and

thirty years for burglary. She wouldn't be eligible for parole for twenty years. Her lawyers appealed the case on the basis that her Miranda rights had been violated, but her retrial was denied.

In 1998, Marcia sought clemency for the murder. She told the Indiana Parole Board that God made her stab and nearly behead Shelly Smith. She said that she felt no remorse for what she had done but that she would not murder again if she were free.

"I think it was a test to see if I would be obedient, and I proved that I was, and the contract is finished," she said during a public hearing. "Yahweh doesn't require me to do that [kill] anymore," she said. "I think Yahweh owes me something this time because of what I did for him."

Needless to say, her request for clemency was denied by the governor.

GREENBUSH CEMETERY

Halloween has become a holiday in America during which people celebrate some of the pagan traditions by visiting haunted houses, reading scary stories and watching scary movies, as well as dressing up in costumes and going out to trick-or-treat. The holiday has its origins in an ancient Celtic festival where the bones of livestock would be thrown into bonfires. Costumes and masks were also worn in an attempt to copy the evil spirits or placate them.

Halloween 1864 was a tragic day for some Union soldiers returning from the Civil War. They got involved in a terrible train wreck not far from Lafayette.

The mishap occurred about eight miles south of Lafayette on what is now known as Dead Man's Curve. A sixteen-car cattle train was coming south from Chicago. On the same track, coming north from Indianapolis, was an eleven-car passenger train carrying about five hundred Union soldiers going home on leave. We will never know exactly why these two trains collided on the curve. Some say it was because one train was late; others say it was the fault of a new time schedule. Neither of the trains had a flagman at the curve, as was the required rule.

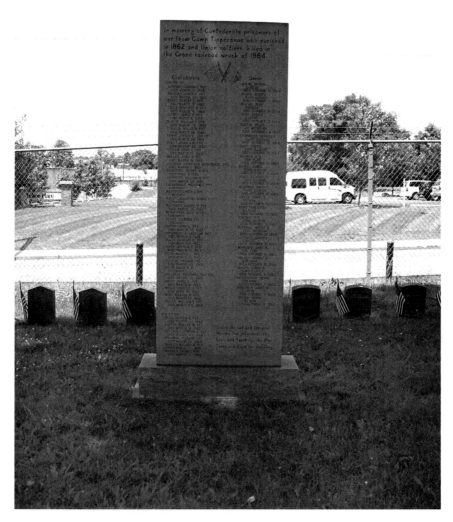

This large monument at Greenbush Cemetery carries the names of the Civil War soldiers lost in the train wreck on Dead Man's Curve. *Photo by W.C. Madden.*

Whatever the cause, it was too late to avoid the crash by the time the engineers saw the other train. Many were injured and thirty-five were killed. Doctors offered medical help from Lafayette, and farmers in the area offered assistance and provided rides into the city.

Most of the dead Union soldiers were buried at Greenbush Cemetery in Lafayette. Their names are inscribed on a large monument, and the soldiers are buried in a row of stones marked "Unknown."

Now on Halloween, it is said that people in the part of the country near the crash can hear the sound of a speeding train followed by a horrendous crash.

THE GHOST OF WHITE WOLF

The "Ghost of White Wolf" was first written about in a Lafayette newspaper, the *Courier*, in 1872. It was written about again in a more recent book, *Tippecanoe*, in 2000. A woman from a local group of storytellers also relates the story to people. It goes something like this.

A newspaper editor, a local judge, a professor and two men gathered one evening in 1872. The editor told the group about a "haunted house" on the edge of town on North Street. Lafayette was much smaller back in those days.

They took a carriage to the location, which is where Sunnyside Middle School now stands. When they got there, they didn't notice anything unusual but decided to wait. They went inside. About 10:00 p.m., a strange blue-white light entered their room. It suddenly burned white and formed the image of a white wolf. At first, it trotted and then ran. Then it raised its head and howled. Next, it formed the image of a froglike creature with alligator jaws and a tail like a kangaroo. It floated in the air for five minutes! Then it changed again to an Indian with a tomahawk in one hand and a blazing torch in the other hand. The Indian walked outside and disappeared.

The professor claimed that he could bring the Indian back, so he went back to the carriage to retrieve some device that could help him do so. He came back with the contraption and was able to get the Indian to

reappear. The Indian said that he was White Wolf and then showed them a tattoo on his arm that resembled the froglike creature they had seen. He said he was buried near Longlois's trading post (near Spring Vale Cemetery). The Indian said he had reappeared because city dwellers had disturbed his rest with their shovels.

Nobody has seen the Indian or the white wolf again, but stories are still being told about it.

THE WARRIOR'S TOMAHAWK

The tomahawk was an axe native to North America and used by Native Americans as a general-purpose tool or as a thrown weapon. Antique tomahawks can be worth a lot of money nowadays.

Amy Prior lived with her husband and children in Lafayette near a local hospital. She described her home as cheerful and full of life—the kind of house that, when you enter, you just know that you're home. Obviously, Amy loves her home and is convinced that the following story had nothing to do with her house, but rather with an object that was brought into the home.

Always moved by Native American history and art, Amy had a large collection. Amy could probably pass as an Indian herself with her long brown hair and brown eyes. Several years ago, her husband won a bid on eBay for a Native American tomahawk. The listing stated that the tomahawk once belonged to a Seminole warrior, the seller's great-grandfather. The tomahawk had several feathers attached that were said to represent winning battles, deaths and so on. It was a beautiful tomahawk, well preserved in a shadow box. Amy received the tomahawk as a Christmas present and immediately put it on display in her family room.

It hung above the fireplace and became a focal point for the room. Almost at once, strange whisperings, odd noises and shadows became apparent. This kept the family in a constant state of nerves. One January evening, while Amy's sons were playing a game on the family room floor, the tomahawk suddenly sprang from the wall and landed

right in the middle of the boys' board game! Startling the boys, they were certain that it had not fallen from the nail but rather had flown several feet!

Amy promptly hung it back up and secured it with strong anchors, but a few days later it leaped from the wall again and made a great commotion as it did so. The family was eating dinner in the next room. Upon investigation, they found that it had flown from its place above the mantle clear across the room! Feeling uneasy, Amy decided to put the tomahawk in the hallway closet. Still the noises and whisperings continued. The family was at a loss about how to resolve the matter.

On another occasion, some birds flew into the living room through the fireplace. She thought that maybe they had left the flue open and that their arrival had nothing to do with the tomahawk.

One evening in late February, as the family was together watching a movie, they received an unexpected guest. All was quiet, and the only light was the glow of the television while the family of four watched the comedy on the screen. A black mass, like a low fog, seemed to appear directly in front of the TV. Floating about three feet off the floor, it shot across the room, leaving a cold draft in the room. Amy screamed! Her husband and sons leaped for the lights. That was enough for the whole family. It was decided that the trouble started with the tomahawk and that perhaps the spirit would follow the tomahawk if they got rid of it. The next day, Amy's husband dropped it off at a local Goodwill store.

That very evening, the house felt different. A peaceful feeling seemed to come from every room. The family never experienced anything unusual in their home after the tomahawk was removed. Amy is certain that the warrior who once owned the tomahawk is still attached to it. To this day, she prays for his soul to find peace.

BIGFOOT

Some have called it Yowie, Yeti and, of course, Bigfoot. This creature's name is one that many, if not all of us, have heard since childhood. What exactly is a Bigfoot? The Native American legends refer to the creature as "Sasquatch" or "Tak-he," which means "hairy giant."

Bigfoot experts estimate that between four and six thousand such creatures roam the forest of North America. Reports are often made in midwestern states such as Indiana where the population is rich in deer. Although many believe these creatures to be vegetarian, it has been reported that they may capture and kill young deer for their livers.

Accounts of Bigfoot in the Lafayette area go way back. In the early 1800s, reports were made about large creatures seen in the night running across farms and killing livestock. In June 1883, a reporter for the *Indiana Gazette* named A.W. Hoffman wrote a story about a wild beast that residents claimed terrorized the Lafayette area.

Eventually, one man claimed that the beast turned out to be a "regular gorilla" that was seven feet high, weighed about three hundred pounds and had red hair. The man claimed to have captured the gorilla, which of course was not proven because it had escaped.

Later, a claim was made that the one-time captured gorilla had a mate. The pair was reported playing havoc in the vicinity of the Wabash Valley. A large brood of chickens had been taken from the coops and devoured. Never was there any proof other than the claims of many that these beasts seen were indeed gorillas.

As recent as October 2004, Bigfoot was reported being seen by a couple driving home. At about 8:30 p.m. one clear fall night, a husband and wife were driving about two miles north of Buffalo—about forty-five minutes north of Lafayette—near the Tippecanoe River. The surrounding terrain along the road was wooded farmland, which had recently been harvested along the river. They thought it was just another normal drive home.

The couple was staying at a cottage by the river north of Buffalo. After a busy day, they road quietly and were anxious to get home. As they were driving at about fifty miles per hour, the couple was shocked

to see a creature larger than any human cross in front of their car. The creature was covered in hair, stood upright on two legs, was maybe eight feet tall and had long arms. It just walked at a normal pace, seemingly unaware of the car approaching. Looking straight ahead as it walked, the creature disappeared into the recently harvested field, fading into the darkest of night.

Their windows had been up, and they claim they didn't hear any sound come from the creature as he walked. Frightened as they were, the couple drove for home, locking all the doors and windows, still in shock! Had they just witnessed a Bigfoot? They believe without a doubt that this is exactly what they'd seen.

On another occasion, Joey, a Cutler resident, was fishing along the Wildcat Creek with his nephew, Nathan. They were fishing alongside the creek when large stones came from somewhere above them and landed in the water with a driving force. Next they heard what sounded like large trees being shaken. Knowing that it would have taken a lot of strength to throw the stones the way they'd fallen or make the noise they had heard, their good sense told them that it was time to go. While the two were walking away from the creek, they came upon a very large barefoot print. Toes could clearly be seen, and Joey snapped a picture with his cellphone, knowing that this was not a human footprint. Joey and Nathan believe that they were not alone by the creek that particular day. Bigfoot was nearby!

Joey and Nathan were not the only ones to claim to have had a run-in with Bigfoot along the Wildcat Creek. In the summer of 2005, retired brothers John and Marc were fishing along the creek not far from Adam's Mill, located northeast of Cutler on County Road 50 East, about a half hour ride from Lafayette. The fish had been biting that day, and their cooler was full. Just before sunset, the two men were preparing to leave and carrying their things to the parking area.

There were only a few cars left in the lot, and as they were about fifteen feet from their car, a creature walked right past the back end. In fear, John dropped the cooler, and it made a loud noise as it hit the ground. This made the creature turn and look in their direction. For just a moment, it stood there, glaring at the two with very dark eyes. Then the creature

A Cutler resident spotted Bigfoot close to this area of Wildcat Creek near Adam's Mill, east of Lafayette. *Photo by W.C. Madden.*

Lafayette Haunts

turned back in the direction he was walking. John and Marc watched as he continued to walk past a building and around the back, where he disappeared. Recovering their composure, the brothers gathered their things in a hurry and drove away, not bothering to recover the fish that had fallen out of the cooler. The description the brothers give is of a creature between seven and eight feet tall and covered in reddish-brown hair with long arms. The creature's face was somewhat like a prehistoric man's, with large-boned eyebrows and dark, piercing eyes. When the creature walked, its arms swung and its back was slightly bent. Looking back, they wish they'd found the courage to investigate more at the time.

Often throughout history, claims were made of witnesses seeing towering, manlike apes covered in hair. Could the early residents of Lafayette have been seeing Bigfoot? Considering that so few would have ever personally seen a gorilla, it is not hard to believe how they could have mistaken a Bigfoot for one. After all, it would be a more comforting thought to think that you were being stalked by a gorilla instead of an unknown beast.

The question still remains: "Does Bigfoot exist?"

LAHR HOTEL

The old Lahr House (later Hotel) became a spooky place after June 12, 1876. That was the night that James A. Moon took his life using a gadget resembling a guillotine.

The farmer from nearby Wea Plains, twelve miles south of Lafayette, had decided to do himself in. He tried chloroform twice, but each time Lafayette police officers revived him. Then the ingenious man decided on something more foolproof.

He loaded up the materials for his contraption and checked into the Lahr House in downtown Lafayette on the corner of Fifth and Main Streets the morning of June 12. He told the clerk that he wanted a room for a week. He had a rather large trunk, so the two-hundred-pound man elicited the help of a bellhop.

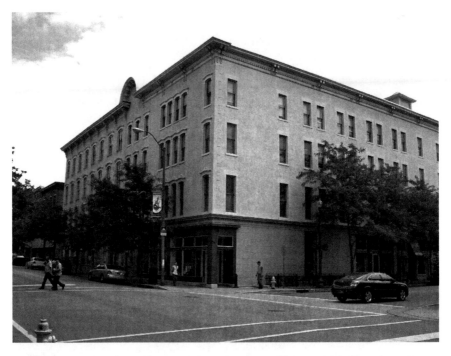

This building was the Lahr Hotel until the 1950s. James Moon took his life with a guillotine there. President Ulysses S. Grant once attended a banquet at the hotel. *Photo by W.C. Madden.*

After he checked in, he went and had a shave. Then he met with some former veterans with whom he had fought in the Civil War.

Later that afternoon, he started putting together his device. His hammering disturbed his neighbors, so the manager came to ask what all the commotion was about. Moon told him that he was putting together an invention. He had a huge tomahawk fastened to a hinge device on the floor. He suspended it with a cord to a hook fastened low on the windowsill. He also put together a box for his head to fall into.

He placed himself beneath the tomahawk and stuffed a cotton ball saturated with chloroform inside the box next to his head. A candle on the windowsill slowly burned through the cord and sent the tomahawk down on his neck. It worked just fine. The next morning his body was discovered.

The manager retained the guillotine device to display to hotel visitors and made the Lahr Hotel a popular tourist stop. The hotel, which began

in 1848, went out of business in the 1950s. Mark Twain was once a visitor, as well as President Ulysses S. Grant. John Purdue also made it his home for awhile.

Apparently, suicide must have run in his family. His son committed suicide in Kansas in 1900, and his daughter did herself in at a Chicago apartment one year later.

INDIANA KNIGHTS OF PYTHIAS HOME

Back in 1926, construction was started on an elaborate structure in Lafayette. The Knights of Pythias built a large building on the south side to house orphans and lodge members. The new Indiana Knights of Pythias Home was dedicated on August 10, 1927, and the first occupants moved in on December 1 of that year.

For a decade, the orphanage served them well, but then the Knights of Pythias turned it into a retirement center for lodge members. In 1942, it opened its doors to the public for lack of use. Later, it became a nursing home for the general public. While it was a nursing home, several people died within the structure. The Will County Ghost Hunters Society said there were ghosts seen and voices, footsteps, cries and moans heard there. Perhaps those cries came from the ghosts of the former patients who died there.

The nursing home met its demise in the early 1990s, and the building was sold to the Lafayette School Corporation. The corporation allowed the First Edition, a club of the Jefferson High School Music Department, to use the facility as a "Haunted Mansion" in the late 1990s and into the new century. Live actors would scare the daylights out of the guests. The fundraiser was highly profitable.

According to one website, a Purdue student, who was working one night at the mansion by himself, heard three different screams and then a pounding noise within the elevator. He knew that no one else was in the building, so he tried to ignore the eerie sounds and concentrate on his work. The more he tried to ignore the sounds, the louder the pounding got. Then the noise suddenly stopped, and the elevator doors opened. No one was inside—or at least no one human.

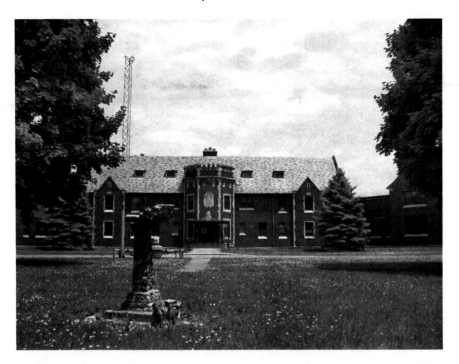

The Knights of Pythias Home was used as a haunted house and may really be haunted. Now it is vacant. *Photo by W.C. Madden.*

Then the Indiana Ghost Trackers made a visit to the place for a couple of days and witnessed the ghosts themselves. The group was able to obtain several voice recordings, photographs of orbs and energy readings. "I believe there are some presences there," Tracker president Mike McDowell said in 2001.

When a couple of workers got sick after cleaning up bird droppings there, use of the haunted mansion was halted indefinitely. Other past workers at the home said that things would get moved around, and the lights would go on and off sometimes. One worker got so frightened of the place that he quit.

Now it just looks haunted.

SCARY CEMETERY

Going home late one dark night, a local Lafayette resident decided to take a shortcut through an older local cemetery. The burial ground was located at North Twelfth Street with busy streets nearby.

The area had been the setting for many scares in Scott Whitman's youth. He and a group of friends would seek adventure playing pranks on one another near the cemetery in his adolescence. One of their favorite games to play was hide-and-seek as the location only added to the thrill.

Scott claimed that the games came to an abrupt end one afternoon when his friend Eddie fell, hitting his head, knocking him unconscious and ending with a concussion. That was the last game that the boys had played together. They carried him home to his parents, knowing that they were in a great deal of trouble. Eddie's mother was hysterical as she had the boys help her put him in the car and take him to the hospital.

That evening when Eddie came around, he claimed that he had seen a black shadow rush by as fast as lighting, and suddenly he received a strong push from behind, knocking him to the ground. His parents insisted that he had imagined the event and forbid Eddie from hanging around with Scott and the other boys. The next year, the family had moved out of state.

On this particular night, Scott pulled on his sweatshirt, lifted his hood and walked very fast. Although it was a late May night, there was a chill in the air. Frequently, he found himself glancing over his shoulder. He could not escape the feeling that someone was following him. As he walked along, he was reminded of Eddie's story. Reflecting back, he remembered the color of Eddie's skin when they came across him. His complexion was unusually white for his normally olive skin tone. At the time, Scott was more concerned for the trouble they were in and his friend than what actually may have happened. In fact, he admits that he always felt Eddie must have imagined the whole thing, but that opinion quickly changed that evening as he walked alone through the cemetery.

As he neared a plot, he heard a rattling noise near a headstone. Thinking it must be a rodent, he quickened his step. Again the feeling of being followed intensified, and he was regretting his choice to walk

through the cemetery. The moonlight broke through the darkness, and he peered curiously around, stopping in his tracks when he heard an echoed whispering to the left of him.

Scott turned his head in the direction of the sound, and to his horror, he saw what appeared to be a white shape bobbing up and down close to a tombstone. He didn't wait to investigate and hastily left for home and safety. Running blindly into the darkness, he didn't watch his footing and stumbled over a stone, landing on his knees. Sweating despite the coolness of the night, he regained his strength and stood ready to bolt again when a dark shadow went past him. Not able to control the shaking of his hands and the wobbling of his knees, he fled for his life for home.

When he arrived home, his twenty-four-year-old brother Bryan was there with his girlfriend. The couple was startled when Scott burst in the door out of breath. He related his tale with much color and enthusiasm. Unfortunately, he was known for being a prankster and was not taken seriously. Still, Scott stuck to his tale until his brother agreed to go into the cemetery the next night and investigate.

The next evening, Scott remained home while Bryan and two of his friends went into the cemetery armed with flashlights. Thinking this was nothing more than a way to calm the nerves of his younger brother, Bryan and the boys had a few beers before they left for the cemetery, figuring that they might as well have a good time while exploring. They were all a little light-headed when they arrived. The group first found the atmosphere to be calm as lightning bugs fluttered by.

When they ventured farther into the cemetery, they claimed that the air got considerably cooler. They huddled together and talked about it. Then the group became suddenly quiet. A humming sound seemed to be coming from all directions. The sound was not very loud and seemed to vibrate throughout the area. Not sure what caused the sound, the boys decided that it was time to leave—none wanted to admit how frightened he had become.

By the time the group had reached the house, they decided that the sound must have been from a distant train. This theory made sense to them and helped calm their nerves. Inside the house, they assured Scott that there was nothing to be afraid of and that their investigation turned

up empty. Still certain that he experienced something paranormal, Scott shared his story one afternoon with an elderly neighbor. He was surprised when his neighbor, who had lived in the area his whole life, wasn't surprised with his story and believed him fully.

Several years ago, he went on to tell Scott, some local boys set up a ghost watch at the cemetery. There had been a few ghost sightings, and after a third by a reliable resident who claimed to see a bobbing ghost by a headstone, some of the braver males decided to set up watch. They armed themselves with shotguns and a lantern.

The first few nights passed quietly, and the ghost watch had nothing to report. But then late one evening, they heard a muffled moan, a moan that sounded like that of a cow. Then they heard a rattle, and a white object could be seen bobbing up and down in the distance.

The petrified amateur ghost hunters found the courage to pick up the lantern and raise their rifles ready to shoot. As they got closer, the white object seemed to disappear and a black shadow seemed to shoot across the area back and forth several times with the speed of a locomotive. In terror, the boys began to shoot as they ran for safety. This did little to help the situation and only resulted in one of the boys skimming another's arm with a bullet. Although the wound was not life-threatening, the man reportedly told his friends, "If I don't make it, don't bury me here. There is an evil waiting in the shadows."

When Scott's neighbor finished the story, a chill ran up his spine. He returned home and told his brother that he was moving and did just that within the week. Moving several miles from the cemetery, he still had nightmares of his evening stroll.

Almost twenty years later, Scott has never returned to the cemetery and refuses to drive by the neighborhood in which he grew up. Over the years, he has heard occasional stories regarding that particular cemetery and often stopped the tellers before they could share their story. He had had enough and laughed as he told me that he bought his burial plot well into his mid-twenties just to be certain that he was not laid to rest anywhere near the area responsible for so many sleepless nights.

ST. ELIZABETH MEDICAL CENTER

Not too many years ago, the condition of healthcare was not what it has become today. Many of those who had hoped to be healed within the walls of old hospitals perished from the lack of knowledge that we now have. Hospitals were an emotional place for those being treated and their love ones, as well as for the doctors and nurses devoting their lives trying to heal the sick. Before different vaccines were created, illnesses like tuberculosis, polio and the flu took many lives, despite the best efforts of the medical staff. It's no surprise that a hospital would hold a great deal of both past and present energy, which only heightens paranormal activity.

St. Elizabeth Medical Center in Lafayette is one such hospital. The hospital is located at 1501 Hartford Street and is owned by the not-for-profit St. Elizabeth Regional Health, a division of Sisters of Saint Francis Health Services.

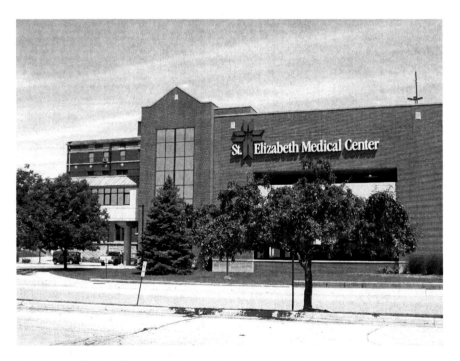

St. Elizabeth Medical Center in Lafayette. *Photo by W.C. Madden.*

Diane Williams spent several weeks visiting the hospital when her mom was recovering from a severe stroke in the fall of 1997. Her mom had been ill for awhile and was living with Diane when the stroke occurred in nearby Delphi. Her mom was taking a nap at three o'clock in the afternoon when Diana was on a phone call just outside the bedroom on the attached deck. She paused in mid-conversation when she heard her name being called softly. The voice that had come from within the bedroom sounded like that of her deceased father. Not sure if she was hearing things, Diane ended her phone call. Just as she set the phone down on the table beside her, a voice called her name again—she was certain that it was her father's this time. The voice was firm and loud. Although she felt frightened, she was compelled to go directly inside the room. This was when she found her mother frozen in time and called for an ambulance.

Overcome by worry about her mother, Diane didn't think about the voice that had gotten her attention until much later. The week that followed was full of anxiety and sadness. Her two siblings flew in from Texas, and other family members and friends visited Diane at the hospital to offer support for her mother. As the weeks went by, everyone seemed to go back to their normal lives, leaving Diane with their heartfelt prayers. She no longer had the distraction of family members to help ease the days. The hospital staff was very comforting and offered all the information they had and kept her well informed when things had to be done or changed concerning her mother. Still, Diane felt very much alone.

One afternoon, Diane was just about to enter her mother's room when she paused in the doorway. She saw her deceased father standing beside her mother's bed, smiling down at his wife. Diane's mother had been nonresponsive since her stroke, but she noticed that her mother seemed to being staring right back and smiling. Diane took a few steps backward and felt horrible. A nurse asked if she needed anything. Diane looked away from the scene in front of her and over at the nurse. She was unable to speak and could only point at her mother. The nurse looked into the room, and the image of her deceased father was no longer there. Her mother seemed to be sleeping. The nurse told Diane that she should rest awhile in the waiting room because she was looking pale.

When Diane entered the family waiting area, the room was empty. She lay down on the sofa and closed her eyes. When she opened them again, she saw that it was dark outside. She sat up immediately and realized that a woman was sitting in the chair nearby. The room was dark, the only light coming from the hallway outside the door.

"Everything is as it should be," the woman suddenly said with a thick accent. Diane looked over at her. She appeared to be in her thirties and was of average height and weight. This woman wore a long black dress that came up close around her neck. Her hair was pulled back into a bun with loose brown curls escaping at her temples.

"Excuse me?" Diane said to the woman.

The mysterious woman gave her a soothing smile and said, "Don't be sad. Your mother has gone home to her loved ones. She feels no more pain."

This immediately made Diane's stomach flutter. "My mother? What are you talking about? Who are you?" All these questions flowed out from Diane all at once.

The woman didn't answer in English. She smiled and softly said something in a language that Diane didn't recognize. Then she faded in the darkness of the room.

Feeling like a small child afraid of the dark once again, Diane shook with fear. Just when she was about to run from the room, a soft knock sounded from the doorway. A nurse and the hospital priest kindly asked if they may speak with her. The doctor joined them in a private room, where they gently broke the news that her mother had peacefully passed away in her sleep.

Diane felt numb as the events of the day had yet to register. The next couple of days seemed like a dream; Diane was just going through the motions. During the funeral, many family members remarked to Diane and her siblings that their mother was once again reunited with their father. This brought back the scene Diane had seen in the hospital the afternoon of her mother's death. This time the image did offer Diane comfort that her mother was not alone. She shared this with her siblings and was shocked to learn that her brother had thought he heard his father's voice in their mother's hospital room the last day he was there before returning to Texas.

The thought of their parents together once again was very pleasing to them.

A couple of days after her mother's death, Diane returned to the hospital to pick up a few of her things. The staff at the hospital was as considerate and kind as she had always known them to be. When she was walking to the end of the corridor, a nurse that had been on duty the day her mother died called to her. She asked if she could walk with her a moment. Diane could tell that she seemed a little uncomfortable but waited patiently for her to get to the point of the conversation. She became soft-spoken as she stopped walking and turned to Diane. She told Diane that she felt uncomfortable talking about this after her recent loss, but she felt like she should. Just before her mother had died, the nurse noticed her mother walk into the hallway. She seemed to be healthy and was smiling. The form of a larger being was right beside her. The nurse couldn't make out the other form. They seemed to just float up and disappear into the wall. The whole thing happened so quickly! The next thing the nurse knew was that they were alerted of the heart rate and blood pressure change from her mother's room. Then her mother passed away.

Diane told the nurse that she was grateful for her sharing this. She went on to tell the nurse about the things that had happened to her the day of her mother's death. When Diane told the nurse about the strange woman with the accent in the waiting area, the nurse looked shocked. She said a man awhile back had said that same thing happened to him in that waiting room. His description was the same as Diane's. The only difference was that the man had seen the woman standing by the window and described her black dress as very old-fashioned. This particular man had served in World War II and recognized the woman's language and accent as German. He'd heard many Germans speak when he was in the war and was confident that he recognized the language. She was very comforting to him, as she appeared very real until she suddenly vanished before his eyes. He had also seen the woman the day his wife died. The nurse also shared some other stories of spirit sightings at the hospital she has heard over the years. A fellow nurse had seen a little girl in a gown walking toward her in the corridor before she vanished, and

another hospital worker had seen a strange ball of light float down a hallway. Never had she heard of anyone ever being harmed by anything they'd witnessed.

Diane left the hospital that day with a completely new view of the afterlife. She now believes without a doubt that the soul lives on and that she will one day be reunited with her parents. She is also thankful for the mysterious woman who offered her comfort during her time of need. She even has some theories of who the woman may have been.

St. Elizabeth Central opened when six members of the Sisters of St. Francis of Perpetual Adoration left their home in Germany in 1875 in order to commit their lives to caring for the sick in Lafayette. The hospital opened in 1876. In 1897, the St. Elizabeth School of Nursing was launched.

Diane believes that the woman she met was one of the original women who started such a great institution. A woman with a heart so big and caring would still want to be a source of comfort to the living in the present from beyond the grave. The St. Elizabeth staff may not be the only ones offering care and comfort to the family at this historic location. The doors of the hospital will be closing soon. Will the mysterious woman also relocate to the new hospital that is being built?

PART II

WEST LAFAYETTE HAUNTS

PURDUE UNIVERSITY

The Ghost of John Purdue

On the campus of Purdue University, the grave of its namesake is located right in the middle of campus. Naturally, there are many and varied stories involving the ghost of John Purdue.

John was born on October 31, 1802, in Pennsylvania, the only son in a family of ten children. He arrived in Lafayette in 1837. At age sixty-seven, he offered the state $150,000 of his own money, $50,000 in pledges from others and one hundred acres of land in the little town of Kingston—now West Lafayette. In return, the state agreed to name the university after him and allowed for him to be buried on campus.

An abandoned house once sat at the edge of Purdue's campus. According to legend, the house was once occupied by John Purdue's mistress. The house has since been demolished to make way for campus expansion. Some have claimed to see a raven-haired beauty in a long white gown weeping. She has most often been spotted along Purdue's Memorial Mall.

One legend involved the lion's head fountain. Campus legend said that the fountain would spout water when a virgin walked by. After the fountain was rehabilitated, the legend changed. When a virgin walked by, you might hear the low rumble of a lion. The virgin is a symbol of purity, and the lion's roar is demanding that she be given respect. The legend will one day be forgotten or perhaps changed to fit the time.

A former student, Richard, recalled that his most memorable moment at Purdue involved a supernatural encounter. He claims to have been

This headstone marks the grave of John Purdue, whom Purdue University was named after, and he is buried there as well. *Photo by Dorothy (Salvo) Davis.*

standing by the lion's head fountain talking on his phone when suddenly before him stood a beautiful young woman. She appeared to be as solid as any human. Her only oddity was the long gown she wore, which was apparently from another era. The dark-haired beauty seemed to be pleading with her damp eyes. She stared past him. The hairs on the back of Richard's neck stood up as an electric current could be felt in the air surrounding him. Richard looked over his shoulder right into the eyes of a man obviously not of this world. The man wore an old-fashioned brown suit with a bow tie. This apparition appeared to be in his sixties, and he had a round face with strong features around the eyes. His eyes were looking past Richard to the woman over his shoulder.

What frightened Richard the most was that he seemed to be in the center of a magnetic field created by these two beings. An invisible force seemed to be pulling these two entities toward each other without ever completely bringing them together. Shock of what he was experiencing took over and caused him to drop his phone. Time seemed to freeze. When the last grain of sand dropped through the hourglass, Richard regained control over his body, and he bent down to pick up his phone. Suddenly, the man was gone. He turned his head quickly in the direction of the woman and caught a final glimpse of her flickering form before she faded away.

Looking back, Richard feels that he witnessed true love and the power it can hold beyond this life. The experience he had does not haunt his dreams, and he now hopes that he, too, will find someone who will create such an emotional charge—his true love.

The sightings of the mysterious woman and the man are interesting because that is the final resting place of John Purdue himself. The man who gave money, land and his name to Purdue University requested to be buried on campus when he passed away. The university granted Purdue's wish and buried him on Memorial Mall, just east of University Hall.

Purdue Airport

Purdue University, like many colleges, is known to hold claim to its own urban legends and ghost stories. Perhaps the most famous ghost to have been spotted at Purdue University in West Lafayette is Amelia Earhart.

In 1932, Amelia Earhart became the first woman and only the second person to fly solo in a plane across the vast Atlantic Ocean. She held a number of aviation records, which in her own time was no surprise from a woman who before the age of ten built her own wooden roller coaster. Her records were held until 1937, when she attempted to complete the famous flight around the world.

In the fall of 1933, Amelia Earhart spoke to a large audience at Purdue University. One of those in the crowd was then university president Dr. Edward C. Elliott, who held a special interest in the education (and belief in the education) of women. He felt firmly that Earhart was a fine example of female ambition and an excellent role model for the female students. After expressing this to Amelia in November 1935, she happily accepted the position of visiting faculty member in the Woman's Career Department. She was also given the role of advisor to the Aeronautic Department.

Amelia was said to spend a lot of time at the university, giving lectures and speeches. She took encouraging students very seriously and spent a great deal of time at the university over the next year and a half. Her husband, George Putnam, whom she married in 1931, would later write, "She found her time at Purdue as one of the most satisfying adventures in her life."

Amelia was known to express publicly her great love and joy of being part of the great university. The purchase of a Lockwood Electra through Purdue University enabled Amelia to fulfill her dream of circumnavigating the globe by air.

Earhart disappeared at the young age of thirty-nine just shy of her fortieth birthday (1897–1937). On July 2, after completing nearly two thirds of her historic and published flight, over twenty-two thousand miles, Amelia Earhart vanished along with her navigator Frederick Noonan. A great naval, air and land search failed to locate Amelia, Noonan or any trace of the aircraft.

To this day, their fate is the subject of endless speculation, mystery and debate. Not just in regard to Amelia's life on earth, but also regarding her appearance, said to have been spotted after death. Hangar number one at Purdue's airport has had a number of reports revolving around Amelia Earhart's ghost. Crew and maintenance

members have claimed for years to see a figure of a slender woman in pants and an aviation coat with a scarf tied around her neck fitting Amelia's description. She appears to be standing in the shadows around hangar number one. Just outside the hangar, it has been reported that an officer with the National Guard was so startled by the sudden, almost transparent apparition of a woman that he fired shots at her. Later, he claimed that the woman seemed to melt into the air.

Also reported was the sighting of a tall and slim dark-haired man leaning against a wall outside the passenger terminal building. He wore a suit pleated of the '30s era and seemed to have his eyes set on the sky. Although he stood perfectly still with his head pointed up, his hands seemed to be opening and closing as if he were nervous. On different occasions, as witnesses approached the man, a similar feeling of nerves and sudden light-headedness caused the witnesses to lose their balance. When looking in the direction of the man again, he was gone. This seemed to be a shared experience among different individuals at different

Purdue University Airport. *Photo by W.C. Madden.*

times. Is it possible this figure was that of Amelia's husband George, who died in 1950 searching the sky for his lost love? He is said to have never fully recovered from the disappearance of his bride.

Earhart Hall was where Amelia lived on campus and is also said to be haunted by this famous lady. Students there have reported a cold, unexpected breeze to pass by them when on the first floor. Windows and doors have been reported opening and closing on their own. Items lost and seemingly gone have reappeared in plain sight.

On more than one occasion, the nearly see-through figure of a woman has been spotted. Students who have claimed to see the woman claim that she has short-cropped hair with kind eyes and a girlish frame. Her clothing consists of slacks and a simple shirt from the 1930s era. A former student claimed to have walked into a room on the first floor and found a woman wearing slacks and short hair, standing with her back to her and staring out the window. The figure was reportedly biting the nails on her right hand as she peered ahead. A moment passed without any movement from the apparition when she suddenly faded into thin air.

Other claims made are the sound of footsteps by the front entrance and the shuffle of paper. Reports of the clattering of an old typewriter have been heard late at night into the early morning hours. The eeriest event was the report of a former student. She had been sharing a private joke with a friend. No one else was around, and when the girls stopped their laughter, they were startled to find a third voice laughing softly right beside them. As the voice dissolved, the sound of footsteps could be heard walking away.

Regardless of the truth behind the death of America's aviation sweetheart, it can certainly be considered that she still does what she loved to do in life: fly.

Although Amelia Earhart vanished over seventy years ago, the beautiful and adventurous woman will continue to inspire. Amelia's is a case that will never officially be closed. Perhaps you will find answers if you are brave enough to seek her out at Purdue's hangar number one.

West Lafayette Haunts

Purdue Engineering Students

Italian immigrants played an important role in the stretching of tracks of the western railroad throughout Indiana. These men were often very hardworking and determined to finish whatever they started in a timely manner. For this particular culture, respect was everything. When treated fairly, they would support their employer 100 percent, but it was fast learned that to disrespect these hardworking immigrants could become a deadly mistake. Early Italians in certain groups were often called mobsters, or the Mafia, simply because they lived by a code of respect. They had a simple rule: give respect and you will get respect. However, if a man was not honorable or no longer trustworthy, he was dealt with harshly as an example and warning to others.

In spring of 2005, a group of young male engineering students from Purdue University were doing some research by the old Wabash train bridge not too far from their campus in West Lafayette. The bridge was first completed in July 1853 before tracks were set. This first bridge was a covered bridge. The current bridge was built after a freight train broke through the bridge in 1924. The bridge has six spans and a total length of 620 feet. The weather was still very cold, and the day was gloomy and dull.

They had been at the location that early afternoon not even twenty minutes when they first noticed something odd. When they were setting up their soil sampling equipment, a cold wind seemed to pick up around them, making the temperature drop by at least ten degrees. John, a twenty-five-year-old environmentalist with the group, bent down to pick up a coil used to test the soil that he placed on the ground with other tools moments earlier. When his hand touched the metal, he let out a loud, painful scream! He dropped the coil and grabbed his hand in pain. Everyone in the group stopped what they were doing and gathered around him. The coil was so hot that it had burned him right through his leather glove!

After a few minutes, they were able to carefully remove the glove that melted around the burn and treated his burn with a first-aid cream from the kit they'd been smart enough to bring. Once John was fixed up until he could get it looked at later, they all went to look at the coil

that had burned him. John was shocked when they discovered that the coil was no longer hot; it was, in fact, freezing cold! The group had no idea what caused the coil to heat up in such a way that it had burned John so severely.

Confused but not frightened, the students decided that there had to be logical explanation and continued with the task for which they had originally come. They gathered soil samples and took different measurements and temperatures. The afternoon went by quickly, and soon it was time to go. When all of the equipment was put away, John was closing the back door to the van when a voice came from behind him: "How's the hand?" The voice had a cruelty to it and was very direct and angry. He turned around fast but saw no one. This unnerved him, and he got into the driver's seat of the van but said nothing to the group waiting inside.

When he was backing up to turn the van around, a backseat passenger screamed, "Look out!"

Hitting the brakes, they all looked behind the van to see a man wearing brown pants and a dirty old button-up shirt standing and staring at them with one strong arm folded over his broad chest. This man was missing an arm and had the look of revenge on his stern face. Then, as if he was transported, he was suddenly twenty feet farther back than where he had just been, still wearing the angry expression on his face and glaring.

John hit the gas as people in the backseat yelled at him to go. Looking in the review mirror, he noticed that the man had disappeared. He kept driving despite his racing heart and painfully injured hand. Despite the high intelligence of this group, they never found answers to what they'd seen. John started having nightmares the very night of the incident. To this day, he continues to have the dreams.

In his dream, it is as if he is watching an old western murder take place. There are four men beating and decapitating a man as they slowly torture him. The man being tortured is the same man he saw that day by the Wabash.

A couple of years after the event, a friend gave him a copy of an old article he had come across. The article is from a May 17, 1885 Kokomo, Indiana newspaper:

Kokomo, Ind. May 16—During last fall a company of eighteen Italians procured work on the New Lafayette, Burlington and Western railroad, under the supervision of contractor McCarty, now of this city.

Four of them it seems, rented an old building on the farm of Mrs. Livingston, twelve miles west of this city.

When winter set in and work was suspended these four Italians who were all that remained of the eighteen, worked about the neighborhood at odd jobs and lived as best they could, until Tuesday the 5th, in hopes of getting wages do to them from the railroad. The Monday following the men had been seen burning rubbish near their cabin. Tuesday they boxed up their things and hired Buck Livingston to take them to the Flora station, in Carroll County, stating to Livingston that they were going to Chicago.

No one was absent and the remaining three bought tickets to Cincinnati, Ohio. Nothing more was thought of the matter until Thursday morning, when Buck Livingston and W.T. Kelly went to the shanty and discovered an old mattress and two pillows in the house badly stained with blood. This aroused suspicions and that immediately instituted a search of the premises. On going down the ravine one hundred yards from the house, they discovered a fresh pile of dirt in a secluded place, and were soon horrified at finding a man's arm. They quit digging and sent word to Coroner Smith, of this city. The Coroner had the whole body disinterred, and it was identified as that of Antony Nicoli, the boss of the laborers and a subcontractor on the railroad works. He had a rope about five feet long around his neck and had his skull crashed in by what appeared to be the pole of an axe, or a heavy club. The rope was used to drag the body from the scene of the murder to its burial place.

There is some evidence going to show that the other Italians had threatened him, believing that he was responsible for their pay, and this was most probably the cause of the murder. Nicoli had neither money nor valuables otherwise to tempt them for the deed. The last seen of Nicoli alive was Saturday evening, May 2nd. This night, it is believed by the neighbors was the time of his murder by his companions. The inquest in progress in this city. The three companions last seen with Nicoli are supposed to have gone to Sharon, Ohio, to work on public works.

John believes that the man in this article is the same he'd seen murdered in his nightmare and met that day by the Wabash. Words cannot describe the feeling of deja vu that overcame him when first reading that old newspaper article. His hand shook and the world seemed to spin. After several days, he finally recovered from the shock and now finds himself wondering why he was selected that day to be Nicoli's target. He thinks it may have been his Italian blood. John believes that Nicoli haunts areas along the track, the work on which he likely oversaw. In John's words, "Beware of the old tracks. Nicoli is out for revenge!"

HAPPY HOLLOW PARK

In this day and age, it is hard to believe that life on other planets is impossible. Man was once thought of as crazy for suggesting that the earth was round, and children were once taught that there were nine planets and one solar system. As our technology advances, so does our awareness of the galaxies beyond ours. Modern digital cameras and recorders have captured numerous images of unidentified flying objects. Aliens and flying saucers have been documented for centuries in many different cultures. Why, then, is it so hard for the idea of alien abduction to register with most people?

Joshua, known to his friends as Josh, is a retired pilot and admits that he was among the thousands of nonbelievers until he had a firsthand encounter with an extraterrestrial that he will never forget. A hike after a long day of celebrating forever changed his viewpoint on the reality of UFOs.

In the early fall of 2005, Josh and his wife Karen were wrapping up a surprise birthday party for their youngest daughter. Their daughter had just turned thirty, and the parents went all out for the occasion, inviting everyone they knew to join them at Happy Hollow Park in West Lafayette.

The day had been perfect. Nearly fifty of Josh's family members and friends came, and after a barbecue and baseball game, the large group

This is the entrance to Happy Hollow Park. *Photo by Dorothy (Salvo) Davis.*

took turns taking pictures. The leaves had turned bright red, yellow and orange at the park. Plus, the sunshine, a deep blue sky and white puffy clouds made picture-taking perfect.

Josh was attempting to capture the image of his playful grandchildren and their grape soda pop grins when he first saw something out of the ordinary that day. As the six children smiled at him, he paused as he noticed a strange group of white discs in the sky. Squinting into the bright sunshine, Josh tried to make out the objects. The objects appeared in a straight line hovering just above the trees. They were all shaped like a football and so white that they almost appeared to blend in with the sky. The objects seemed to just float in the sky. Counting three shapes, Josh ran all the possibilities of what the objects could possibly be through his mind. Then, just like the snap of your fingers, they were gone, as if they disappeared instead of trailing off.

Not sure what he was looking at but thinking nowhere along the lines of UFOs, Josh continued taking pictures of friends and family. Still, he

found himself occasionally glancing at the sky, wondering what lucky pilots were likely testing military jets. Josh had more than twenty thousand hours in the sky as a commercial pilot. He would occasionally hear stories of pilots who witnessed strange lights and objects in the sky. However, after all the time he spent in the sky, Josh was certain that if UFOs were real, he would have seen one by this point.

Coming beside him, his wife Karen grasped his hand and gave it a squeeze. She looked at him with pity in her eyes and turned to follow his direction to the sky. Josh had retired recently because of severe arthritis in his hands, and it was a choice that caused him a great deal of remorse. Not wanting to worry his wife that he was feeling down on such a happy day, he smiled and lovingly put his arm around her shoulder. He would forget about any thoughts involving pilots and flying objects.

As the party was ending, only a few family members were lingering, deep in conversation. Josh decided that it would be a good time for him to take a hike on the trails. Dusk was coming quickly, and it would be dark soon. Not waiting for anyone to join him—a choice he now regrets—he walked off from the group.

The weather had been beautiful during the day, but a chill was arriving as the day was turning to night. Josh walked quickly, feeling good about himself, and he moved fast along the path. When he made it about halfway up the trail, he noticed that it suddenly seemed unusually silent around him. The best description Josh could give was that although he was outdoors he had a feeling of claustrophobia, and the air around him seemed heavy.

When he reached the top of the path, on top of the hill, he froze. Not four feet from where he stood was a gray-colored being about three feet in height with a large head. The being's eyes were large and in a way reminded Josh of a mosquito in shape, but of course much larger.

Standing face to face with this being was startling in itself, but the next thing Josh remembers is sitting in a cold but very bright room and viewing pictures of the world in which we live. Past, present and, he believes, future were all shown to him. The essence of what was happening and the scenes he was viewing were very clear to him. He even remembers feeling very tired, more than he'd ever felt in his life, and falling asleep.

The last thing he remembers before he fell asleep were several sets of those mosquito-shaped eyes upon him.

When he woke from his deep sleep, feeling as if hours must have passed, he found himself on top of the hill. Looking at his watch, he realized that it was as if no time had passed at all. On shaky legs, he walked as fast as he could back to his family. As he approached them, Josh saw that they were snapping photos of the sky. He looked up and saw three lights identical to what he'd seen earlier but now in a triangle formation hovering in the sky above. All of this was too much for the retired pilot. To his family's surprise, he fell to his knees and then passed out. Josh is a diabetic, and his family, thinking that his blood sugar was off, quickly came to his rescue.

Later the next day, Josh was awake and still in a state of shock. The images that he viewed were still fresh in his mind, and he felt unable to grasp the reality of it all. The idea of even talking about it at this point would make his whole experience just seem too real. After several weeks, Josh finally found the courage to tell his wife what he believed happened to him. She was a wall of support to him as always. Talking about the experience really seemed to help him deal with what he was going through. Nightmares and panic attacks have become a way of life for Josh even now. After a year of dealing with the anxiety and fear that his abduction caused him, Josh finally went to counseling.

He was surprised when his counselor really seemed to believe him. The counselor was not shocked by what Josh had revealed to him. He couldn't give Josh any details, but he did tell him that he was not the only person he has counseled who has had experiences with UFOs. In fact, he connected Josh with someone else who also had experiences at Happy Hollow Park.

Looking back, Josh still has no idea why he was shown the scenes of our planet at different times or why he was picked. What does it all mean? The story of what Josh experienced has no closure, as he still seeks answers. The only thing he does know is that he believes undoubtedly in the existence of extraterrestrials. Images of the UFOs were captured the day of his abduction. During the sighting of UFOs, the family members had quickly snapped some pictures. His son-in-law gave him copies of the objects they saw in the sky.

For Josh, those photos are the closest he ever wants to get to viewing a UFO again.

The first report of a UFO in Tippecanoe County came in 1897. The *Lafayette Morning Journal* published a story about readers seeing a ghostly, balloon-like object at night.

HAUNTED RENTAL

Students of Purdue University in West Lafayette have reported some strange happenings at Williamsburg on the Wabash apartment complex located at 400 North River Road. The location is so close to the famous university that the apartments are home to many students just starting out on their own. Many of these young adults have just left the safety and security of their parents' home to embark on their own journey through life.

John graduated from Purdue University in 2008 and wanted to tell his story about the apartment at Williamsburg on the Wabash in which he lived during his junior year. The apartment was shared with two other friends who had lived there for some time before he moved in. A previous roommate moved out one morning after he claimed to see two dark figures at the end of his bed. This past roommate was known to party and drink a bit much and wasn't taken seriously.

Needing a third person to cover the rent, John was asked to move in within a week of the vacancy. He felt a strange presence in the apartment on the very first day. As he was unpacking in his room, he felt a cold draft on the back of his neck. All of the windows were closed and no fan was on. Goosebumps formed on his arm and a chill ran down his spine. He turned to leave the room when all three picture frames he just set on the dresser fell over like dominos. The apartment was empty at the time except for him, so he decided to leave for the afternoon. John's new roommates were still making jokes about the expression on the past roommate's face the morning he fled, so John decided to keep his experience to himself.

The Williamsburg Apartments in West Lafayette has been the site of ghosts. *Photo by Dorothy (Salvo) Davis.*

Usually in the hallway, John continued to feel as if he was being watched, and in his bedroom he felt an uncomfortable presence. He recalls that he woke up every morning to find a single penny heads up on his floor. He would check the floor before he went to sleep and find nothing there, only to see the penny appear each morning. He was taken by surprise when one morning he woke to find a penny stuck between his toes. He no longer cared to solve the mystery of where the pennies came from; he just wanted out.

Without even attempting to influence his roommates to understand or explaining the simple but weird truth, he made an excuse and moved out. He regretted leaving the fantastic apartment with all of the features on the property, but he felt he would regret it more if he came face to face with whoever or whatever was leaving pennies in that apartment's bedroom.

John was not the only former occupant of the Wabash Apartments to believe that there was a resident ghost on the property. Holly lived at the apartments for over a year with her best friend and claims that it was the happiest time of her life. She had never given much thought to the paranormal before moving in, but she claims that her first encounter happened in the apartment. She was brushing her long blond hair as she looked in the mirror. Preparing for a night out with the girls and thinking of a certain man, she was lost in her thoughts of the night ahead. Suddenly, she dropped the brush and let out a scream. The face of a young girl with long brown hair was reflected back at her. The image seemed as if it had been standing directly beside Holly. Of course this gave her a shock, but she stayed. After a few nights of bunking with her roommate, she returned to her room.

During the weeks that followed, everything seemed fine. Holly loved the apartment and the community it formed. She was happy and determined to forget the face in the mirror. One evening when Holly and her roommate were taking a walk, the face she had feared seeing again reappeared. As the young women walked past the tennis court, they saw a petite girl with long brown hair standing in the center of the court. She raised her head and looked at the two women. Holly recognized her face at once—she was the girl she'd seen in the mirror. The apparition smiled and waved at Holly and her friend before she faded into a fog and then disappeared.

They turned their walk into a run and headed for their car. Despite the scare they received, both Holly and her friend didn't feel threatened. In fact, that they both witnessed the paranormal event together created a united courage between the girls. Odd things continued to happen, but they never again saw the apparition of the girl. Holly has now changed her position on the paranormal, but despite it all she wasn't about to give up a fantastic apartment. Besides, she felt that walls probably wouldn't stop what she couldn't see from following her. She just learned to coexist.

PART III

BATTLEGROUND HAUNTS

PROPHET'S ROCK

Just a few miles from Lafayette lies the town of Battle Ground, named after the famous Battle of Tippecanoe that was fought there on November 7, 1811. The place of the battle is now called the Tippecanoe Battlefield and is a national landmark, with a monument, museum and recreation area.

The place is visited by thousands each year. In September 2004, a Girl Scout troop visited to learn some history. On a nice autumn afternoon, Nicole and her assistant, Tina, took a group of seven girls to Prophet's Rock. The location is the spot where Tecumseh's brother—Tenskwatawa or "The Prophet," as the whites referred to him—preached and sang to encourage the Indians to fight the white soldiers. He was thought of as a spiritual leader.

Nicole and Tina thought that Prophet's Rock would be a nice place for a nature hike and a reflection of the area's history. The troop from West Lafayette had been discussing Native American history during their last meeting and were also trying to complete a nature badge. Nicole and Tina were also very close friends and had just started another of many diets together. The two women in their mid-thirties were also looking forward to this trip as a chance to get some exercise in.

On arrival, the group immediately appreciated the beauty that welcomed them. Feeling as if the view was a picture painted just for them, the trees were still lush with hints of bright red, orange and yellow. The leaves were just starting to change, and the temperature felt comfortable with a light and cool breeze. The day was clear and perfect for hiking. Each girl had brought a sack lunch, and they had intended to picnic afterward.

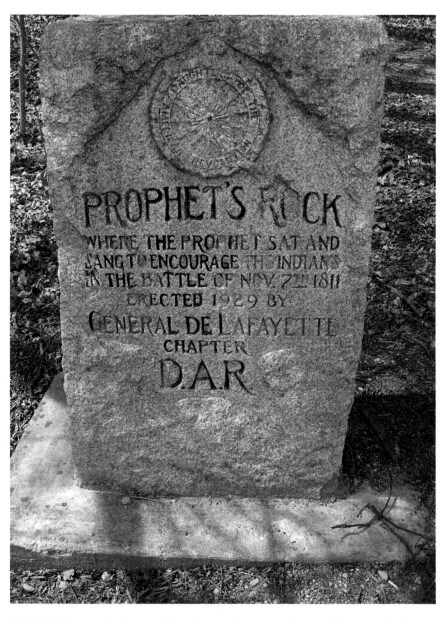

Prophet's Rock marks the spot where the Prophet sat and sang to his comrades. *Photo by Dorothy (Salvo) Davis.*

Battleground Haunts

As the group left their parked vehicles and headed toward the rocks, the leaders immediately noticed a small group of teenagers on a flat stone elevation above them. When the group got closer to start on a path that would begin the hike, the boys seemed to lay flat, as if they had hoped not to be seen or bothered. As they passed by, Nicole could smell in the air a scent coming from the teens above. They clearly were smoking something they shouldn't have been. The stench in the air was so strong that a few girls began to ask what that smell was. The leaders didn't tell them what it was but decided it best to move the girls along fast.

The group was just starting the hike up the hill when one of the girls standing in the center of the line they had formed said, "Wow, look at him run! He must have really fast legs!"

Everyone looked in the direction she was staring but saw no one. Briefly concerned that maybe one of the teenagers from above thought it would be fun to scare the group, Nicole asked the eight-year-old who she

The Prophet stood atop this rock to inspire his comrades before the Battle of Tippecanoe. *Photo by Dorothy (Salvo) Davis.*

was talking about. The girl replied, "The Indian-looking man that was running up the hill."

Pointing to an area several feet to the right, she spoke with such certainty it was if she thought everyone should have seen him run past. Tina asked the girl if she still saw the man. She replied that she didn't. He was now gone.

By this time, the other girls were getting distracted and giggling. Nicole chalked it up to an overactive imagination and moved the girls on. As the group continued their climb, everything seemed to be going smoothly. The girls were fascinated with all that they had seen. Nicole led the way with the girls in the middle and Tina in the rear. The two leaders tried to answer all the girls' questions and enjoyed the excitement with the kids when they passed a bug or saw a butterfly. The climb up the hill was going quickly, and it just seemed to be another well-planned Scout outing.

Then the rush of feet seemed to come out of nowhere. All at once, the whole group paused and stayed perfectly still. The best description Nicole could give was to imagine yourself in a crowded hallway elbow-to-elbow, knowing you were surrounded and just trying to make your way through the crowd. The only difference for this frightened Scout group was that although they could hear the shuffling of feet and feel the breeze of people passing by, no one could be seen! The group froze.

Suddenly, one of the young girls let out a piercing scream. She ran directly for Nicole, and then all the others joined in. This created a moment of panic. The crisp and attractive afternoon turned forbidding and dreary. Trying to keep their wits about them, the leaders attempted to remain as calm as possible and pushed the girls in the direction back down the hill. The invisible presence of others seemed to be going up the hill so the group would definitely be heading down toward their vehicles, or in this case, escape cars.

Not even sure what just happened, the group moved down the hill and off the path. When they had reached the bottom, Nicole and Tina gathered the girls into a small huddle. The leaders didn't expect the girls would want to stay, so they asked them. Laughing at the lunacy of the question at the time, Nicole said they were shocked and not sure what to do next; the leaders found that they were just going through the

motions. A few of the girls were silently sobering and the others were clearly very frightened.

Tina started leading the girls toward the cars when Nicole saw legs dangling over the flat rocks above them in a cavern-like formation in the stones. She saw the smoke drifting up and found herself annoyed that these teens were still lounging around, never even sitting up to check on the group. They had to have heard the hysterical screams from the girl moments earlier.

Nicole could not stop herself as she walked until she was directly below the teens and hollered up that they had better put that stuff out or she would call the police. One of the teens sat up and yelled down, "Relax, you're not our mom, besides we're leaving anyway!"

As the group started down, Nicole said, "You boys should find better things to do with your time."

A short and plump young man with a fresh haircut responded, "This place is mystical! We've seen stuff you wouldn't believe here when we are high."

Nicole found she was disgusted with these boys, but considering what she had just been through, she put her anger at their ignorance aside. Although she knew the Scouts waited for her, she just had to ask, "What have you seen here?"

Another tall and well-built boy with a neat appearance spoke up, "We were here once, and yeah we were smoking. All three of us that day saw a group of Indians below. We heard nothing, but they were there as solid as you are now in front of us. We only saw it that once, but we come back to see if we can recreate what we were doing that day and maybe see it again."

A car horn honked and Nicole knew she had to get going. She told the boys to get on home and headed for the waiting group.

Once they were back, the girls ran to their parents sharing what had happened on their hike. Nicole spent nearly an hour explaining as best she could what she herself didn't understand. She left out the part about the teens, sharing that part only with Tina later that night. To this day, Nicole is convinced that Prophet's Rock holds a great mystery. The events of battle, loss and sadness have certainly left a strong energy at this location.

A great people may have been moved well on earth, but could some have come back to claim this land in the afterlife?

By the way, General William Henry Harrison and his army defeated the Prophet's Indian confederation at the Battle of Tippecanoe and all but ended the Indian wars in the Midwest. Historians estimate that about 50 Native Americans were killed in the battle and about 70 to 80 were wounded. Harrison lost 62 men and about 126 were wounded.

TRAIL OF DEATH

In May 2005, a group of twenty-somethings had just finished their evening shift at a restaurant in Lafayette. The group thought it would be fun to take a Ouija board out to Battle Ground. They had heard stories from others who claimed to see shadows run behind the trees and hear war cries, as well as gunfire.

The Tippecanoe Battlefield Memorial Park was closed to visitors at this time of night, but to the group looking to have an adventure, trespassing just added to the thrill. They parked at a nearby friend's house (who admitted that he heard too many ghost stories to want to go along) and walked with smiles on their faces as they made jokes while heading into the park. The temperature that night was cold but tolerable around the mid-forties, and the sky was clear and full of stars. When they neared the top of a path that led down to the nearby water, they sat huddling in a circle on the ground. Although the scene was a little forbidding, it was also beautiful. Trees spouting leaves dropped seeds that seemed to fall to the ground in slow motion, leaving a mystic feeling to the night. The soft flow of nearby water only added to that feeling.

Joey was a new server at the restaurant at which the group of five worked. He had recently moved to the Lafayette area from California to attend school at Purdue University. The transition had been difficult for the then twenty-year-old. Being new to the area with no friends or family was a huge change for a boy with five siblings and many friends in California. As he recalls the events that took place that night in Battle

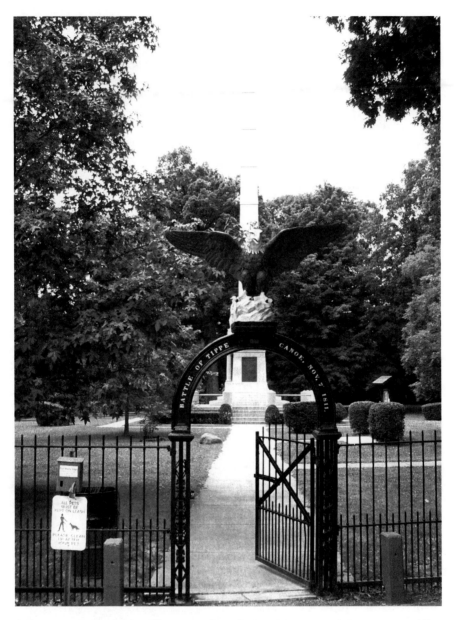

A large monument marks the Tippecanoe Battlefield, and the names of those who were killed are inscribed on it. *Photo by Dorothy (Salvo) Davis.*

Ground, he admits that his desire to make friends overruled his usually good judgment.

Trespassing weighed heavily on the former choirboy's conscience, but he didn't want to appear, in his own words, "like a drip" to his new friends. From the moment they entered the former site of the tragic loss for the Indians against U.S. troops in 1811, Joey felt as if they were being watched. He had grown silent as the others chattered with excitement. The only girl in the group—a petite and pretty redhead—had brought three scented candles. Soon the air filled with the sweet scent of cinnamon apple pie.

With the Ouija board in the center and the candles around the outside of the group, they all placed their hands on the center curser. No one really expected to have anything frightening happen and were giggling and acting silly as they started to ask their questions.

The first question was obvious: "Is anyone here with us?" The curser slid to the word "Yes." People around the circle accused one another of pushing the curser. In good humor they went forward with the next question: "Who are you?" The response they got was a fast "Go." They paused for a moment, listening to the water below. The sound of splashing and water being disturbed, as if someone or something had passed through it, could be heard by the group. Dismissing it as a deer or other animal, they continued.

At this point, it was still believed that someone in the group was guiding the curser. The girl said, "Tell us who you are and maybe we will go!" She said the question somewhat seriously, but she was laughing as she spoke. Suddenly, a strong cold wind blew past the group blowing out the candles. The group took their hands off the curser, and the only smoker pulled out his matches with shaking hands to relight the candles. Confessing that the breeze the group had felt was a little creepy, they turned again toward the Ouija board.

Before they even put their hands back on the curser, it was moving. The group immediately sobered up from the earlier humorous and mischievous mood. They looked on with fright as the curser repeatedly moved from the "G" to the "O" spelling out, "Go" over and over again.

The girl screamed and so did one of the guys. Joey picked up the Ouija board and threw it hard into the darkness. The group picked up the

candles and belongings as fast as they could, leaving the Ouija board and headed back toward the parking lot.

Thinking that his heart was about to explode in his chest, Joey froze. Passing not ten feet in front of them was the shadowed silhouettes of a long line of people sitting atop horses and some shadows of people walking beside the horses. The sound of horses and wagon wheels could be heard, as well as the muffling of voices. The air no longer smelled of comforting cinnamon apple pie but like sweat and animals.

In fact, it was wrenching. After what seemed like an eternity, but in fact was more like a few minutes, the shadows in the front of the entourage, along with the sounds and smell, disappeared into the museum located at the park. The trailing shadows disappeared when they reached the same location.

The group woke up from their frightful, frozen trance and took off running! The term "scared to death" had almost become very real for them. They had carpooled there and drove back to the restaurant, where they'd left their cars earlier in the night. The ride back to the restaurant had been a silent one as they were all still in shock.

The next day, the conversation had been limited when they spoke about what they'd seen. They all seemed to feel that talking about it just brought it back and confirmed how real it had seemed. In fact, the girl in the group never spoke of it to any of them. When probed about it, she would change the subject and become very uncomfortable.

After that night, they never hung out together as a group again. A couple of them remained friends as they had been for many years, but their relationships as a whole had certainly changed. They no longer went looking for the supernatural. Joey became more involved with friends from school and left that job within two months of that frightening night. He has never been back to Battle Ground, but the history of the area has become an interest of his.

Interestingly, he learned that the "Trail of Death" passed right through that exact location. At gunpoint, about 850 Potawatomi passed by there on September 12, 1838, on a 660-mile trek known as the Trail of Death because so many died along the way to their new home in Kansas—mostly children and the elderly. After two and a half months, only about 750 Potawatomi arrived at what is now Osawatomi, Kansas.

They joined other Indians who had also been removed from their homes by gunpoint earlier.

Not surprising to think that a residual haunting (energy repeating itself like a recording) would be taking place at Battle Ground after such tragic events occurred at the location. These events can have a certain day or time at which they occur, known as an anniversary imprint. These residual spirits do not respond or react. However, the interaction that the group received playing the Ouija board would have been the result of an intelligent haunting. In an intelligent haunting, the entity is aware of its surroundings and sometimes interacts with the present. The spirit may even manifest itself!

Regardless of what the group may or may not have experienced on that spring evening in 2005, it's not recommended that anyone play with a Ouija board. When playing such a game, the player never knows what may enter through the doors they are opening. Doors that they may find cannot be closed at will. Nevertheless, proceed with extreme caution when seeking out the supernatural.

TOO CLOSE TO A BATTLEFIELD

Children tend to believe that ghost stories are real, but by the time they grow up, many often consider ghosts to be mythical and out of the realm of reality. This makes it all that more difficult for rational adults to share their personal experiences.

Jessica was referred to me as a woman with a fascinating story of paranormal events. However, I was warned that she might be difficult to get to open up about her experience. She was a victim of ridicule and jokes from people in her previous community.

Nearly twenty years ago, Jessica resided in Battle Ground. Her home was within a mile of the site of the Battle of Tippecanoe. The battlefield has been transformed into a park containing a museum, monument and grounds that educate people about the battle and what led up to it. In the early 1800s, Native Americans were losing their grip on the midwestern lands they had roamed for hundreds of years.

Battleground Haunts

Two Shawnee brothers, Tecumseh and the Prophet, had a dream of uniting many tribes into an Indian confederation against the white settlers. Unfortunately, the dream came to an end in November 1811. A battle between American forces and the federation was waged, and an unknown number of Native Americans died. The battle was a serious blow to the federation.

Jessica was fifteen years old at the time when the strange events started to take place. One night, she found herself alone in her home. Her parents worked late into the evening, and being an only child, she would spend a great deal of time by herself. At first, she heard the sound of boots on the upstairs floor. Then she smelled gunpowder. Although these events were odd, she wasn't alarmed.

One evening, as Jessica was going up the stairs, she heard the swishing sound of a woman's dress glide past her. Looking up the stairs in the direction the sound traveled, she stopped in shock. A shadow in the form of a woman in a long dress glided along the wall.

The Tippecanoe Battlefield was placed on the National Register of Historic Places in 1963. *Photo by W.C. Madden.*

It was several minutes before Jessica regained the use of her legs and went back down the stairs.

No longer feeling comfortable alone, Jessica begged her parents to let her stay with friends in the evening. Thinking that their daughter was foolish, they wouldn't allow her to stay with friends on school nights. Jessica shared her strange encounters with a friend at school. The girl found it too much to keep to herself, and soon Jessica was labeled a freak among her friends. An easy target for their jokes, she now dreaded going to school almost as much as she dreaded staying home alone.

One winter night, her grandmother was visiting for the holidays. As Jessica and her grandmother were playing a game of checkers, the surprising sound of a Native American war cry rumbled through the house. The two stood up nervously and got the shock of their lives. Outside the living room window, the dark piercing eyes of a warrior looked in. The two were very frightened.

They were relieved when Jessica's parents arrived home shortly after the event. Although Jessica was grateful for the shared experience, she was even happier when the family moved a few months later.

Over the years, she thought about contacting the current family who resides in the home to see if they have had similar experiences. Jessica's fear has prevented her, and she is content to never set foot over the threshold of that home again.

TECUMSEH'S CURSE

Shawnee chief Tecumseh was born in March 1768 just outside what is today the town of Xenia, Ohio. He grew up in Ohio County during the American Revolution. Throughout his childhood he was exposed to war. He accurately spoke of the disaster that would be called the New Madrid earthquake. Legends surrounded his curse or, as some believe, prophecy.

In 1808, Black Hoof, a Shawnee leader who was trying to maintain peace with the whites, demanded from Tecumseh and his Confederacy,

as well as Tecumseh's brother, who had a great many followers, that they leave Ohio. They moved farther northwest to where the Wabash and Tippecanoe Rivers (near present-day Battle Ground) meet.

One legend is that following the Battle of Tippecanoe, Tecumseh, forced to release his prisoners, said that Harrison would be elected president in 1840 and die in office. After that, each president elected every twenty years would also die while serving his term. When they died, he said, everyone should remember the deaths of the Native Americans—meaning not only those who died in battle, but also all those who were killed by settlers and soldiers. Also, they should remember all that was stolen from a once peaceful people forced to fight for the homes they had had before whites forced them away.

Another version states that Tecumseh's brother, Tenskwatawa— a.k.a. the Prophet, and a Shawnee medicine man—created the curse. It was revenge for the Harrison-led troops causing Tecumseh's death. No historical documents support the notion that Tecumseh or his brother placed a curse upon the presidents. Of course, considering the era, it would have been passed through the gossip of returning soldiers telling of the heroic battle. However, if it was documented, it may have been kept secret or destroyed. At the time, many believed much of what the Prophet predicted; it was that belief that gave them a united power. After his prediction didn't come true, the tribes were no longer united as one. Any proof that any of the Prophets future predictions came true during the ninetieth century wouldn't have been wanted by the federal government.

Perhaps someone noticed that the twenty-year cycle created the legend or others invented different versions from the story. The only version that can be debunked is that Tecumseh uttered the curse or prophecy while he was dying during the Battle of Tippecanoe. After being defeated, it is documented that Tecumseh and his Confederacy joined the British in Canada and helped capture Fort Detroit during the War of 1812. The Americans then counterattacked, led by William Henry Harrison, and invaded Canada, killing Tecumseh during the Battle of Thames in 1813.

Regardless of any individual's thoughts or opinions regarding curses, it has to be admitted that the following pattern is very interesting. Every

president elected in a year ending in zero, except Ronald Reagan, died in office. Not all died in their first term.

The first was William Henry Harrison—to whose forces Tecumseh lost at the Battle of Tippecanoe—who was elected president in 1840. He died from illness in his thirty-second day in office. Twenty years later, Abraham Lincoln was elected to the office in 1860. He was later assassinated. Twenty years later, in 1880, James A. Garfield was elected to the office, and he was also assassinated. Twenty years later, William McKinney Jr. was elected to office in 1900. He, too, was assassinated. Twenty years later in 1920, Warren G. Harding was elected as president. He died of a heart attack while in office. Twenty years later, Franklin D. Roosevelt was reelected in 1940 and later died in office. Twenty years later, John F. Kennedy was elected to the office. He was assassinated. In 1980, Ronald Reagan was elected to office, and he was nearly assassinated. George Bush came to office in 2000, and three feeble attempts were made on his life during his eight years in office. So, apparently the curse has been broken permanently.

PART IV
WHITE COUNTY HAUNTS

THE SPOOKY RESTAURANT

In the Twin Lakes area about a half-hour north of Lafayette near Monticello is a restaurant that may be haunted—at least for one individual.

A merciless sun heated up the land as Randy climbed farther up the ladder at the restaurant. His large hand held a paintbrush loosely as he wiped the sweat from the back of his neck with his handkerchief. He had started painting only an hour ago, and already half moons of sweat darkened the armpits of his shirt.

Focusing his eyes, he began to carefully paint the trim of the window in front of him. With a steady hand, he carefully finished one edge of the frame and leaned back to observe his work. As he met his reflection in the window, a pair of dark eyes looked out at him. Startled, he grabbed hold of the ladder to balance himself. The eyes belonged to a very lovely lady. She had a familiarity about her that Randy found endearing. In an incredibly graceful action, she bowed her head and disappeared before his eyes. Years later, Randy said about the mysterious lady, "She was the most gentle woman in appearance I have ever encountered."

Randy is not alone in his experience. One June morning, Lindsey, a server at the restaurant, was doing her morning routine. Alone in the dining area, her work was interrupted by the sound of laughter. It seemed to come from right beside her. As she stood and listened for the sound to come again, a table skirt from across the dining room raised up as if a gust of wind had just blown by. Lindsey stood frozen, not sure how to respond, and was relieved when fellow workers began to arrive.

Lee, a kitchen worker at the restaurant when he was a young man, recalls a strange event that took place one night as he and a co-worker were cleaning in the back of the kitchen. They were alone working in silence when suddenly the sound of a man and woman engaged in an intimate conversation could be heard. In their ignorance, they searched for the source once the voices had stopped but could find no one. At first, Lee admits that it did not occur to him that the voices could be something paranormal—only when the bottom of his ankle was grabbed by unseen hands did they stop their search. Lee and his fellow co-worker ran off, leaving their work unfinished.

Cathy, a local resident, was enjoying dinner with her family one evening at the restaurant when she excused herself to go to the restroom. Once inside the very clean and elegant bathroom, she checked her reflection in the mirror. The room was empty, so on her way out she stopped to adjust her skirt. Suddenly, something tugged at her hair! She paused and again she felt a tug. Despite this experience, she says that nothing could keep her from enjoying the restaurant's excellent menu. Cathy laughed as she stated that she will be sure to just go to the restroom in pairs when dining there.

We've left out the name of the restaurant at which these spooky happenings occurred because we want you to still enjoy it without any fear of being scared.

THE WASHINGTON STREET BRIDGE

Mr. Wayne had been crossing the Washington Street Bridge in Monticello daily for five years before he had the scare of his life.

One day, he was on his way into town to meet some friends for dinner when his car ran out of gas. At the time this happened, it was before most people carried cellphones. Aggravated because he was already running late, Mr. Wayne started for town on foot. He planned to meet his friends and have them return him with gas to his car later.

When Mr. Wayne was crossing the bridge, he noticed a group of young people on the opposite side. He claims that they were in their late teens

The Washington Street Bridge was the site at which five were killed in the 1974 tornado. *Postcard courtesy of W.C. Madden.*

to early twenties. At first, he simply observed that they were there and thought nothing more of it. Not until he was directly across from them did he notice they were transparent!

He froze with fear. The group seemed unaware of his presence, and although they seemed to be talking, he could hear no voices. Mr. Wayne willed his legs to move forward with great difficulty. When he got to the end of the bridge, he was unable to stop himself from looking back. The group was gone! Hours later, he was still shaking.

This may have nothing to do with this story, but it was at this bridge that five people perished after their van was sent into the lake by a tornado on April 3, 1974.

GHOST IN NORWAY

Across the Tippecanoe River from the village of Norway stands a home high above the river that was built by a man's own two hands. He put

a lot of work into it. Unfortunately, he didn't have much time to enjoy his labor of love, as he died from pneumonia. Now he haunts the home, which is located about twenty-five miles north of Lafayette.

His ghost was seen one night by Mrs. D.'s current husband. The couple was asleep when her husband was awoken, and he saw the spirit floating above their bed. Then the ghost reached down and stroked his ex-wife's face. Mrs. D. reacted by swiping her face as if she felt the stroke, but she was sound asleep.

Then the ghost floated out of the room and headed toward his children's bedrooms to bid them a good night.

"He lives in the spirit of his children," explained Mrs. D.

She has yet to see him herself, but she has caught something out of the corner of her eye. She just doesn't know if it was him. She feels that he is still around, though, in spirit.

THE BONE

About a half hour north of Lafayette in White County is Lake Shafer, which attracts summer visitors from all over the world since the Indiana Beach amusement park is located there. On a lake road west of the lake sits an average-looking, well-kept home. By the looks of it, you'd never think there was anything spooky about it, but looks can be deceiving. The home was occupied by a couple and their three teenage sons and daughter. Cody was the oldest, with Heather and Chris directly behind him in age. This was a family with a tight bond and respect for one another.

Two years ago, Cody was staying the night on a couch in the family living room. He awoke in the middle of the night and felt like someone was staring at him, but when he looked over at the recliner next to the couch he saw nobody. The next morning he told the family. Heather agreed that she felt a presence in the home sometimes. She swore that someone tugged at her blankets while she slept. Heather eventually became so frightened by this that she began to sleep on the couch in the family room.

White County Haunts

After finding Heather sleeping on the couch, her parents decided to spend the night sleeping in her room. The idea was to prove to Heather she had nothing to fear. The couple didn't get through the first night without being awakened from their sleep. The blankets had been slowly pulled from the bottom of the couple's bed.

They now had no doubts about what their daughter was telling them or anything else the other kids were experiencing. Despite the obvious feeling that another presence was in the home, the family began to believe that the entity wasn't dangerous or evil. In fact, they had a sense that they were being looked after and protected.

Cody came from his dad's previous marriage and moved in with his father and family full time a year later. He knew that someone unseen shared the home but wasn't frightened. In fact, he was the most aware and really became certain that it was a positive energy. This helped his siblings feel more at ease.

One night a month later, someone tried to break into the home, so they called the police. When they responded, whoever it was had gone.

This incident led the couple to install a security system in the home. Not long after it was installed, the alarm started going off for no apparent reason every couple of weeks. The company came out and tested it. They didn't see any problems with it.

One night, the panic alarm went off, but no one had pushed it. Then the phone rang, and a voice warned them to check their doors. They found them unlocked. How that happened, they had no idea. Again the family felt protected, but the feeling was not to last.

While the basement was being refinished that year, they found a human femur bone in the basement. Not sure what to do with the bone, they simply threw it in the trash without any further investigation. The bone was a creepy find, and they just wanted to forget it. After all, it was well known that Native Americans once resided in the area and were buried here.

In the walls they found old coloring books and children's items. Why had a child's items been placed inside the wall? The finding of the bone and other items changed the energy felt throughout the home. The feeling was no longer positive, but rather a very dark force. The father had become the target for this dark energy. He went from being the kind

This house near Lake Shafer on Lake Road is haunted. *Photo by W.C. Madden.*

and easygoing husband and father they had always known to an easily aggravated and quick-tempered man they no longer recognized. As the months went by, his relationship with not only his wife and children but also others who knew him began to change. Despite his wife's best efforts, she seemed unable to repair their weakening relationship. His children no longer wanted to be around him.

The joy the family once knew was quickly fading from their minds. One evening during an argument he was having with Chris, his wife knew that this wasn't her husband. During the argument that she had to break up, she looked into his eyes and saw pure evil. The man she'd known and loved for years had never worn that expression. She needed help.

Finding the courage, she spoke to her husband one day, telling him she thought he needed to receive a blessing. To her surprise, he confessed that he felt as if he had no control over these angry feelings. He said that it was as if he were inside himself not wanting the cruel things to come out of his mouth but that he had no control. He hated feeling this way. The family soon had their home blessed and the husband as well. As if a cloud had been spread apart, allowing the rays of sunshine to break through, the heavy, dark feeling left the home. All became calm again. The positive entity can still be felt, but the darkness is gone for good, the family hopes.

These strange happenings will always leave the family wondering. What was that dark force that grabbed hold of a member of their family, and could it happen again?

WHERE TRAGEDY LINGERS

Can a tragic event actually leave an imprint of negative energy? Some believe that it can. On Northwestern Avenue in Monticello, there is a plain but neat rental home. The home does have the benefit of being located close to shopping and businesses, but nothing particular stands out about it. If you were to simply drive by it, it would not likely even catch your attention.

White County Haunts

This particular home has been the residence of many victims who have passed tragically to the other side. Just over a decade ago, a son murdered his father in the home that belonged to the family at the time. Supposedly, the father was abusive to both his wife and son. One evening the son had enough of the abuse and shot his father. When police arrived, the mother feared for her son and claimed that she had shot her husband in self-defense.

In another instance, a baby passed away at the residence from Sudden Infant Death Syndrome, breaking the hearts of a family who lost a child too soon. Not so long ago, a teenage boy who had moved into the home on Northwestern Avenue met with a sad end. The teen was a mentally handicapped boy and is remembered as being very sweet and caring. One winter he fell through the ice at Blue Water Park in Monticello, resulting in his death. No doubt the family mourned for their loss in the home.

This rental house on Northwestern Avenue in Monticello has seen its share of tragedies. *Photo by Dorothy (Salvo) Davis.*

Could these past events have created a negative vibe in the home? The house is now a rental property that doesn't seem to hold its renters for very long. A past resident claimed that lights went on and off by themselves, and doors opened and closed. There was often a feeling of being watched, and normally happy people would suddenly become depressed. On a few occasions, strange sounds could be heard in the dark hours of the night.

Ghosts are nothing more than masses of negative energy. Naturally, they seek an environment that has an abundance of such energy. If the house has enough negative energy, ghosts, evil spirits or victims of premature deaths will be tempted to enter and haunt it. Perhaps the negative energy is what results in repeated devastation at the same home. Maybe it is cursed, and positive energy is the key to break it.

A Monticello woman was searching for a rental house in the summer of 2009. She went to the house on Northwestern Avenue and took photos of the exterior to later show her husband. When the couple looked at the photos together later that day, they were shocked to see a transparent man in a couple of the photos. He was tall with wide shoulders and looking out of a front window of the house. It was clear that you could see right through him in the photograph. Of course, the couple passed on looking at this house any further.

A property can become haunted if there happens to be an abundance of negative energy inside, so always remember to live your life full of love and laughter within the walls of your home.

BROOKSTON

Just north of Lafayette is the quaint town of Brookston. It has the picturesque charm of many small towns in America: the town hall, the town marshal, the annual Apple Popcorn Festival, a German bakery, an antique store and so on.

Jessica loved driving through the town five days a week to travel from her home in the small community of Reynolds to her job in

West Lafayette. She came to know how the appearance of the seasons would be reflected in the homes and yards as she passed along her thirty-minute route. She knew which house grew what flowers and which houses had different fall foliage. Needless to say, this time each day became Jessica's time for herself to regroup her thoughts. Her favorite part of the drive was Route 43, which passes directly through Brookston. She so loved the town she even once attempted to talk her husband into moving there.

On a clear evening in spring, Jessica was heading home from a difficult day at work. She was driving on Indiana Route 43 and was almost to the town of Brookston when she became very frustrated. Traffic in front of her was slowing down and eventually crawled to a stop. A street worker was flagging traffic up ahead to one side of the road. After a trying day, Jessica really wanted nothing more than to go home, let the dog out and soak in a hot bath.

Knowing that she had no choice but to wait, she inserted her Reba McEntire CD into the dashboard player and let out a breath. Patiently, she waited for the long row of vehicles in front of her to be directed forward. Her mind began to wonder as she thought of what she would be making for dinner that evening and if her husband remembered to drop off some packages at the post office earlier that day.

When Jessica turned her head to the right and looked out the window at a house off the road, she immediately came out of her dreamy thoughts and was alert. A strange figure crossed the yard in front of the home. Not yet frightened, Jessica rolled down the passenger window of her Jeep Cherokee and got a better look at the woman wearing a long, flowing Victorian-style dress that appeared to be blue with small things, possibly flowers, along the high neckline. Her hair was held high on her head in a tight bun, and despite the long dress with wrist-length sleeves, the woman seemed to be very frail and tiny in form.

Not knowing why just yet, the hairs rose on the back of Jessica's neck. She looked at the vehicle behind her to see if the passengers had taken notice of the oddly clothed lady. Looking back, she saw a man in a black pickup truck deep in a conversation on his cell phone. She knew this because he moved his hands quickly as he was speaking, and she guessed

A ghost has been seen along this stretch of Indiana 43 near Brookston. *Photo by Dorothy (Salvo) Davis.*

that he wasn't at all aware of what was happening outside his truck. Turning her head back in the direction of the woman in blue, Jessica's mouth fell open and she froze. The Victorian-dressed woman moved as if someone hit forward on a remote control and pointed it at her. As if she was gliding through the air at the speed of light, the woman became a blur as she rounded the side of the house. Feeling shaky and light-headed, Jessica couldn't believe what she had just witnessed. The woman moved at an unnatural pace and then just disappeared! How was that even possible?

The man in the truck behind Jessica honked his horn as the flow of traffic moved forward. Her heart pounding in her chest, Jessica replayed over and over what she had just seen in her mind. She knew without a doubt that she had just seen her first ghost or had her first paranormal experience! Always when someone spoke about seeing something they could not explain, Jessica would roll her eyes and tell herself that they either had too much to drink or had an overactive imagination. This theory didn't apply to Jessica. She was a healthy and fit woman in her thirties. She was five-foot-six, 120 pounds and almost never drank unless it was a special occasion. How could a rational and intelligent woman such as herself just imagine what she knew without a doubt had been before her very eyes? This was deeply puzzling to her and caused her to reevaluate her belief in life after death and the possibility of being visited by the dead. Wanting to make sense of this unexpected awakening she was having, Jessica considered returning to the home at which she had seen the lady disappear. Her husband, having never himself experienced anything paranormal, had no belief whatsoever. He put his foot down and insisted that his wife forget what she thinks she saw and move on.

To this day, Jessica holds firm that she saw a lady in blue disappear along Route 43 just outside Brookston.

Another man claims to have seen a black cloud skim along the road for about a quarter of a mile in the same area years ago. Strange.

White County Haunts

The Haunted Top Notch Bar

Brookston is a town with tree-lined streets and charming homes surrounded by flowers—a town that could be the perfect setting for any all-American small town. To sum up Brookston in one word: charming.

Despite the obvious beauty, the small quaint town has had its share of tragedy. The saying "the calm before the storm" is often a very accurate description of many unwelcome situations. The history of many battles speaks of numbers of men waking to a beautiful sunny day during war that was to be their last. Considering that scenario, it's not surprising to learn that a gruesome murder took place in the beautiful town of Brookston not so long ago.

Like many small towns, Brookston has an annual festival—the Apple Popcorn Festival. There are over two hundred craft booths, contests, entertainment, music and a great variety of food booths. Yard sales are scattered throughout the town. Brookston's annual festival takes place on the third Saturday in September. This is the time to celebrate the local harvest, rich with apples and popcorn. Railroad and Third Streets are closed off for the festival and fill fast with patrons crowding the streets.

In 2004, a couple visiting Brookston for the fair were having such a great time that as evening was approaching they hated to see the fair end. They had heard that there was to be a dinner at the elementary school and thought they might check it out. Well, they were passing the Corner Pub located at the corner of Third Street and Indiana 43 and saw a young girl standing in front of the Top Notch Bar a few doors down at 113 East Third Street.

The young girl caught the couple's attention because she was dressed in early 1900s clothing. The girl wore a lacy off-white dress that fell just below her knees. The puffy sleeves came to her elbows, and she had on dark stockings and shoes. She had a sash tied around her waist. With shoulder-length curly brown hair, the girl couldn't have been more than nine years old.

Thinking that there may be a reenactment happening somewhere, the couple walked toward the girl to ask. Standing in front of the window of the Top Notch Bar, she just seemed to be observing everyone as they'd walked past her.

This is the Top Notch Bar in Brookston. Besides ghosts, it's been visited by Governor Mitch Daniels several times while he has been in the area. *Photo by Dorothy (Salvo) Davis.*

Keep in mind that the street was still busy with fairgoers maneuvering past one another. The couple was occasionally bumping shoulders with others. Just a moment before the couple was about to approach the girl, they were stunned to see a woman push a stroller right through her. Halting in their steps, it took a moment to register what they had just seen. The couple then saw no sign of the young girl.

Although they witnessed a ghost from the past observing the modern community, the couple still makes the special trip to the Apple Popcorn Festival each year—only they keep their eyes open for another glimpse of the young girl in the lovely early 1900s dress.

Interestingly, the Top Notch Bar was the A.B. Garrot Drygoods and Notions store in 1902. The couple who owned the store did have two young girls. In fact, old photos of the store show a young girl of about nine, which fits the description of the girl the couple had seen. Another strange assumption is that she may be a young girl who died of the Spanish flu in 1918 while staying at the Myers Hotel. The A.B. Garrot store was later changed into the Myers Hotel. In 1914, the hotel was very busy with railroad travelers staying the night.

The Top Notch Bar building has seen its share of different businesses throughout its history. When entering the bar, it gives one a warm feeling with its scenery. Today, the bar is owned by Gary and Pam Hendryx. The couple has worked hard to reinvent the bar, but it still keeps the small-town vibe. The saying "clean enough to eat off" doesn't even begin to describe the neatness of the restaurant and bar. The kitchen is immaculate with stainless steel shining and everything in its place. This bar has a reputation for such fantastic food that people regularly make the short drive from Lafayette to enjoy a burger or steak and the friendly atmosphere. The bar's slogan is "Great steaks, no bull." The couple is very open and honest about their resident ghost. Pam says that the ghost is harmless, and she respects his being at the Top Notch Bar. She uses the word "his" because she believes the ghost to be that of a man who was murdered there.

In June 1965, a murder occurred in Brookston at the bar. Two employees of the Top Notch Bar, then owned by Hollace Shipley, shared the apartment located above the bar. On the night of June 5, Kathryn Newkirk fatally stabbed her lover, Lawrence "Bunk" Switzer.

According to Newkirk, she got off work that evening at ten o'clock and attempted to enter the apartment around eleven but was unable to do so. She went and visited another tavern for a couple more drinks and then returned to the apartment. Bunk opened the door, and immediately the couple began to argue. Kathryn believed Bunk to be sleeping with another woman, which he denied. She claimed that he began to physically accost her. Kathryn then told police that after Bunk hit her she was afraid and went into the kitchen, where she grabbed a knife.

Deciding to leave the apartment, she went into the room that she and Bunk shared to grab some belongings. That is when she claims Bunk began to scuffle with her. Trying to get away, Kathryn claimed that she accidentally hit him with the knife. The next thing Kathryn remembered was Bunk crying out that he was hurt bad and asking her to go for help, which she did. Kathryn got the town marshal, who called Dr. Gish. The doctor didn't make it in time. Lawrence "Bunk" Switzer was pronounced dead at 1:25 a.m.

Kathryn Newkirk was indicted for second-degree murder on June 17, 1965. Her trial began that October. Witnesses contended that on the night of the murder Kathryn didn't have any noticeable bruises or scratches on her body. The marshal said that although there was blood on her dress, it was not torn. Still, witnesses admitted that Bunk was known to have a fierce temper when intoxicated, which he was the night of his murder. Based on this and other evidence, Judge Russell Gooden sentenced Kathryn to the Indiana Women's Prison for not less than two or more than twenty-one years on October 7, 1965. Kathryn served one and a half years and was paroled on July 7, 1967.

Although this was shocking and horrific to the usually peaceful and quiet town, the residents mourned the loss but put the ordeal behind them. Gary and Pam had heard the story of the murder that took place at the Top Notch Bar but still decided that this was the business for them. Pam first began to believe the bar was haunted when glass would suddenly fly off the shelf behind the bar. On other occasions, people would hear the sound of someone walking in the empty apartment above the bar. The bar also experienced strange electrical problems. They have had some appliances fixed only to see them break again.

White County Haunts

A few times, the local police have found the door leading to the upstairs apartment wide open after the bar was closed for the night. After inspecting the building, the cops would find it empty. Even more puzzling was that Pam herself would secure the door and lean objects against it to make it impossible to open from the outside. Still the door would be found open some mornings.

Pam is a tiny little lady with a big heart. She is the type of person who makes you feel like you've known her forever after a moment of just meeting her. Gary has the same likable personality, and an intelligence can be seen in his eyes that make him seem very genuine. No wonder the ghost of a murder victim may still want to hang out with this comfortable couple after his tragic passing.

Eddie Bogan of Lafayette agrees that the food is fantastic at the Top Notch but also claims that the entertainment can be equally as fantastic—that is, if you don't mind being scared nearly to death. On a summer evening in 2008, Eddie was meeting a friend at the nearby video store. He was waiting in his car across the street from the Top Notch. He had just happened to look up in time to see a woman in what he thought looked like a rave dress pacing back and forth. Her hair was in a bop, and the lavender dress was short with a pointed white collar.

Something about her seemed unusual, but he couldn't put his finger on just what. Suddenly, she seemed to stomp her foot and turn abruptly toward the side front door that led upstairs. Without any hesitation, she simply vanished as she passed right through the door! Eddie didn't feel comfortable waiting for his friend any longer and left for the most frightening trip home he ever had. Any minute, he thought, he would find the girl sitting in his backseat. Of course, he didn't, but the fear he felt never left him. Who was the strange woman? Could she have been one of Bunk's old girlfriends come for a visit?

When Gary and Pam moved into the building, they soon discovered that Bunk's belongings were still upstairs. Pam even came across a bloody sheet, and the old-fashioned tub that Bunk had lain in, dying, now sat on its side in the kitchen. The apartment has been empty since his terrible murder. Pam knows that with the large size of the one-time hotel rooms and beautiful woodwork, the space has the potential to become something

wonderful once again in the future. For now, she gives Bunk a respectful space, even calling up a "Hello" before entering what she considers his apartment. There is no doubt to the Hendryx couple or anyone else who has encountered something at the Top Notch Bar in Brookston that it is indeed a haunted building.

WOLCOTT

Wolcott had a public pool for some time, and one day about a dozen people at the pool saw the transparent form of the marshal walk clear across the water and disappear before their very eyes. They said that he had on an actual badge identifying him as the marshal.

Another ghost story in the town that went around for awhile concerned the reappearance of a shack on a clear night behind the historic Wolcott House. The house on the National Register was built in the 1860s, and it once had a shack behind it. It's no longer there…or is it?

MONON

About a half hour north of Lafayette is the small town of Monon. Back on December 12, 1922, the *Monticello Herald* reported ghost activity in the town.

The newspaper reported that a real ghost was spotted by the roundhouse for the past ten days by night crews who were working there:

> *The ghost appears in the midnight hours and is described as a white object, woman shape and size at first then becoming more ethereal, growing to the height of 40 to 50 feet. Most of the performances are given on the cinders back of the round house. It is suspected that possibly a bloody murder has been committed somewhere near and that the place is haunted.*

White County Haunts

A posse was organized, and it waited one night for the ghost. After waiting to near midnight without seeing the ghost, most of the crowd left. However, three brave souls stayed and saw the ghostly figure at about 12:10 a.m.

The roundhouse became the talk of the town, and the newspaper invited everyone to observe it in the middle of the night.

PART V
CARROLL COUNTY HAUNTS

DELPHI

On a small isolated farm near Delphi, a determined woman lived alone with her young daughter and their dog in the early 1940s. This was a hard time for many in the area, including Ada, a widow at only thirty-seven. The past year had been very trying for her as she lost her husband, and her young son Robert had been taken from her to serve overseas in World War II. She found that keeping herself busy was the best distraction for the anxiety she felt for her son. Her eight-year-old daughter Lucy was a bright spot in her otherwise sad and lonely life.

They made a living selling fresh eggs and produce from their large garden, as well as making fresh cream and cheese. Years earlier, this had been a heavenly existence, but without her boys, the work was hard and seemed unfulfilling. Ada didn't want her daughter to sense the sadness that was consuming her. She did her best by making games out of their work, often making Lucy giggle so hard that tears would fall from her blue eyes. Ada was a mother with a strong love and connection to her children.

One night, as she was going about her chores, she became conscious of an odd whistling sound somewhere outside. It seemed to surround the house, but it didn't sound like high wind in the pine trees, noises of nature or a human whistle. The sound was very strange. Curious, she went to the farmhouse door and stepped onto the front porch. As she did, she noticed that her basset hound, Bo, was barking and howling on the back porch. This was odd because Bo would often bolt in the direction of most noises.

Ada walked around to the back porch. She found Bo still barking but not moving from where he stood. As she bent down, Ada noticed that her beloved dog was trembling. Sitting beside him on the front step, she listened to the odd sound. When the noise finally stopped, Ada went inside and checked on Lucy. Amazingly, she was still asleep. Ada wasn't afraid of the sound she had heard. She was simply puzzled by the noise and fell asleep thinking of her son and his safety.

After the evening meal the following night, Ada and Lucy were braiding a rug when the whistling sound came again. Bo, who had been lying nearby, came to Ada and hid under her apron. Lucy looked at her mother wide-eyed as Ada went to the front door and opened it.

The wavering and high-pitched whistle seemed to be coming toward the house from across the fields, yet it was as hard to locate as the chirp of a cricket. It must be some of the local youngsters trying to frighten her, she thought. She remembered a few weeks earlier when she had chased off a few kids stealing eggs. Ada shut and bolted the door and then hastily got her late husband's revolver, just in case. After the noise stopped, Ada returned to the porch with the revolver in hand and Bo at her feet. Telling Lucy to stay inside, she sat down and waited for the pranksters to dare and show themselves. After an hour of quiet, Ada returned inside, thinking that the sight of her with a gun had frightened whoever was out there.

Later that night, Ada awoke with a start. Bo, who had fallen asleep on the front porch, was barking at the whistling sound that seemed louder than ever. As she ran from her room to check on Lucy, the whistle sound came nearer. Although Ada could see nothing from where she hid in the corner of her daughter's room with Lucy in her lap, the sound seemed to reach the house. The whistling seemed to be at the back porch and then turned, passing slowly around the house, and approached the front porch, where the now hysterical basset was almost beside himself with excitement.

Soon there was a terrific outcry from Bo, and sounds of the dog struggling with someone on the front porch were terrifying. With fierceness, the house suddenly shook as if a bomb had hit it. Then silence. Ada, alone in the stillness of night with her daughter, shook with fear and a sense of dread. She didn't dare go out onto the porch despite her desire

to go to Bo's rescue. Eventually, mother and daughter fell asleep huddled on the floor.

The next morning Ada investigated. Bo was gone—no sign of him left to be found. In reality, there was no sign of the struggle she had heard on the front porch. Also, there was no damage anywhere from whatever had shaken the house so violently. With fear for her dog Bo and her daughter's safety, Ada and Lucy headed to their nearest neighbor to seek help.

That afternoon, Ada sat in the home of John and Vivian while her daughter played out front with their two daughters. She recalled the events of the previous nights. Knowing that there was true fear on Ada's face, John grabbed his rifle and along with his fifteen-year-old son headed off to search Ada's property. Ada's husband had been a close friend of John's, and he felt obligated to look after his widow and daughter. After Robert had left for the war, John and Vivian had attempted to convince Ada to come stay with them. Of course Ada, being the strong-willed woman that she was, refused. In truth, John admired her courage and determination to stand on her own until her son returned.

John and his son searched the farm and nearby fields. Finding no sign of Bo, they were about to call it a day when they made a gruesome discovery. They found the lower torso of what they presumed was Bo in a field closest to the house. After searching a few more hours, they were able to find most of Bo and bury him. Not thinking it possible before, they felt that a coyote or wolf might have been responsible for the mutilation of the dog.

That evening, they gave Ada and Lucy the bad news and insisted that they stay with their family. John offered to make trips to her farm and take care of the livestock. Ada and her daughter did stay with John and Vivian, as she still felt shaken by what had occurred. John went for her things, and the next few weeks passed peacefully.

After almost one month, Ada felt secure enough to return home. All seemed back to normal as the mother and daughter harvested their garden and prepared for the nearing winter. Sometimes in the evening they would listen, afraid that the strange sound would return. Thankfully, it never did. A few months had passed when Ada received the hardest news she ever had to accept. Her son Robert had been killed a few months earlier as a result of strategic bombing.

Today, Lucy is an old woman recalling those days of her childhood as the hardest she ever lived through. The day the news came of her brother's death still haunts her dreams. She has never heard wailing like that which came from her mother all those years ago. Ada never fully recovered from the loss of her son. Often she sat on the front porch of the house as if in a trance. The games she played with Lucy seemed to be harder for her to pull off. Many times she would just stop in mid-game and walk away, sitting quietly with tears in her eyes.

As time went on, Ada would often claim that the night the whistling sound was heard must have been the time of her son's injury. Ada had got it in her head that the first night was a warning being sent to her from the other side that her son was injured and needed help.

The second night when the house rumbled as if a bomb had hit it was the night her son had died, she believed. The dog was an example of what had happened to her son. What it was that had created the whistle sound was never discovered, and what happened to the basset hound was never found out.

Ada tortured herself with the unknown experience for the rest of her days and died young in a mental institution. Lucy left home at fifteen, marrying her neighbor's son and moving to Indianapolis. She tried to leave the fear of those few summer nights in the past, but she never could. Watching her mother die of a broken heart, Lucy never allowed herself to have children.

The intensity of a mother's love was too frightening—it was a thing that Lucy felt she could never bare. Regretfully, hers is a sad story of love, loss and regret. Smiling, Lucy assured those who read her story that she believes in heaven and will be at home with her parents, brother and husband soon. This alone gives her some comfort.

LAKE FREEMAN

During the summer, many people in Lafayette travel a short distance to Lake Freeman to enjoy some boating and camping. One place on the lake is haunted with the spirit of the previous owner.

Carroll County Haunts

Back in 1926, a hotel called Roth Park was built on the east side of Lake Freeman, which had been formed when Oakdale Dam was built. Owner William Roth had a place that offered swimming, boating, dining and dancing to the summertime visitors. The place was very popular. That all changed due to fire.

First, William's son, Jack, died in a fire at his cottage in February 1956. He suffocated from the heat, and his body was burned up in the flames. His body was found face down next to his bed. "They had to scoop his remains up with a shovel," explained Jim Clay, who heard about the story after he came to work there in 1965.

Then in February 1961, a fire destroyed the hotel. The damage was estimated at a quarter of a million dollars. A new hotel was built and became known as the Pirates Roost at Roth Park. The place had glamorous dining and dancing, according to advertisements. Although it was sited on a lake, the ad said that it was the most exciting showplace on the seven seas.

The Pirates Roost was owned by Steven A. Young and Mahlon Kerlin, who also owned Sayco in Flora. That company made plumbing fixtures. "They bought it as a tax write off," Jim explained. They would bring in sales representatives and customers during the summer to wine and dine them.

Jim began there as a musician in a band. He would play three times per week. He loved to play the drums in the band and was following in the footsteps of his father, who was a musician as well. Then Jim became a bartender in the galley. When he became a second cook there, he started living there as well. He lived downstairs, and the bar was upstairs. That's when the place started to become creepy to him.

At night he heard strange noises coming from upstairs. "There were these two full-sized statues of pirates, and they'd walk around at night," he explained. He also heard the jukebox come on by itself at night.

One morning, he walked into the bar and a glass of ice was sitting on the bar, but nobody was around. He could have sworn that one of the pirates might have started making himself a drink but heard him coming and went back to being a statue. He checked around, and nobody said they had poured a glass of ice in the bar.

The Pirates Roost was located along Lake Freeman and was the site for the ghost of Jack Roth. *Courtesy of White County Historical Museum.*

Jim got a little nervous about the situation, so he purchased a shotgun and a pistol and kept them in his room for a little security.

One night while he was in his room, he heard the door open. "Then I heard footsteps shuffling down the hallway," he said. The ghost went past his door and went around the corner from his room. Then he heard some keys rattling. Apparently, the ghost was trying to get in the dishwashing room, which was padlocked. "I had a butane lighter, so I went to see who it was," he commented. The hallway was pitch-black. He had trouble getting the lighter on, and on the third time, it lit up like a flamethrower, which was scary enough in itself. He saw the light switch and turned it on, but he could see nobody around.

This incident led Jim to purchasing a dog. The small dog was a mix and had some cocker spaniel in him. "Dogs don't image things," he reasoned. One night he was sitting in his bed when the room turned ice cold. He had a pole light in the corner of the room, and it started to fall over slowly, like someone was guiding it to the floor. The coal-black dog yelped as it came toward him. Jim jumped up and stopped the pole from crashing to the floor.

He went to a fortuneteller in Laporte to see what she would have to say about the matter. "She was very spiritual," he said. The fortuneteller told him: "You live in a great big building. I see white papers everywhere. I see you working in and out of a bar. Who's Jack?" She was right on target with her observations. The white papers she referred to were in the stock room.

He explained to her that Jack had died in a fire.

"There's a spirit where you live," she added. "It is dangerous. Be careful."

That trip to the spiritualist made Jim even more afraid of the ghost of Jack Roth. One night, he was eating supper in the Pirates Roost with his dog along with him. Suddenly, the dog yelped and wet on the floor. Jim looked over and saw a globe of light about the size of a basketball floating about a foot off the floor past the dog. "I couldn't get him back upstairs after that," he explained.

One night after work, he and his friends were playing on the Ouija board, and the pointer just flew off the board on its own. Another time, the board took about an hour to spell out a message: "If I went down

there after midnight, the devil would barter for my soul," it said. Jim was so scared that he grabbed up his pajamas and went somewhere else to spend the night.

One November night, he was in the midst of constructing an ice sailboat for the winter to sail on Lake Freeman. He was drilling some holes when the room turned freezing cold. It scared him so much that he left for the night for Monticello and spent the night in his car.

At another time, he was in his room when a fellow musician from the band called Snobia came to his room for comfort. "By God, the ghost is here," she told him. He let her in to spend the night.

In 1980, the Pirates Roost was sold to a national concern and became White Oaks on the Lake, a time-share facility and RV park. The building that housed the Pirates Roost turned into a dining facility.

Jim, who had gone to work for Hicks Gas in Monticello, had to make a delivery there. He was a little leery of the trip as he didn't want to go back there, but it was his job. While there he asked if they had heard about any of the ghost stories there. They responded positively. Then he added that he was in the middle of some of those tales. They told him about a more recent scary story at White Oaks. They said that one night the security guard didn't show up for work. When they went looking for him, they found him frozen to the bar, and they literally had to take him out of the place. He quit immediately, so they never found out what had scared him so much.

Although the Pirates Roost was a scary place for Jim, it is where he met his wife of thirty-eight years. Myrna had been a waitress at the place. She never saw any ghosts there, but she didn't live in the place like he did before they got married.

Today, the sixty-seven-year-old gray-haired man works at Indiana Beach, working as a cook and ride repairman. He has no desire to return to White Oaks, although he offered to take us there. We told him that wasn't necessary. "I image his [Jack Roth's] spirit is still there," he explained.

PART VI

WARREN COUNTY HAUNTS

THE GHOST OF BLACK ROCK

You've probably heard the expression "Bad Day at Black Rock." The phrase actually refers to a movie of the same name from 1955. The *Black Rock* was also a British ship that went down in the 1800s. The ship was found on the television series *Lost*.

Of lesser fame is the ghost of Black Rock near Lafayette. About twelve miles southwest of Lafayette along the Wabash River on the way to Independence is a geological formation called the Black Rock. The rock is about 150 feet above the surroundings and is where Native Americans from Ohio, Indiana and Illinois met. On a high bank opposite the rock was where religious ceremonies were held. It has been the subject for several writers.

Black Rock was first written about in 1890 in the *Lafayette Journal* by a writer calling himself "Morning Glory."

That writer also said that the rock was guarded by a ghost. Fishermen supposedly saw a pale opalescent light flickering from the mouth of a cave overlooking the river. They also saw a skeleton form by the rugged entrance. The journalist wrote that "there sat a skeleton bathed in the strangest light that ever shown on land or sea."

Morning Glory climbed the rock until he "stood in the presence of the celebrated 'Ghost of Black Rock.'"

The ghost asked him, "Who are you? And what imp of Satan brings you?"

"I am a correspondent of the *Lafayette Journal*, and I wish to interview you."

The Black Rock, at which the Native Americans used to gather, is now a reserve. *Photo by W.C. Madden.*

The ghost then bowed, dusted off a rock and offered the writer a seat.

"How long have you haunted this rock?" the writer asked.

"Only about 150 years, although I have known this country for ages. I lived here in the flesh in the year 900 and was chief." Tears filled the ghost's eyes.

> *This country isn't what it was in those days. The stream at our feet was a mighty river spreading from bluff to bluff and carrying fleets of canoes filled with my painted people. Those were stirring times, and 'tis hard for one who lived in them to be a mere shadow, condemned to sit idle year after year with no companions but cold serpents and insensible rocks. The serpents do not fear me, and I would not harm them if I could.*
>
> *The meanest creature of the Great Spirit has the same right to life that you have, so beware how you live it if you would be happy hereafter.*

I slaughtered anything that stood in my way, man or beast, and now I am being punished for it.

I was killed in a battle with poisoned arrows, and found that dying is no fun. The tribes buried my body with ceremonies befitting a great chief. I watched it all poised in air, a free spirit.

The writer asked, "Have you ever left earth?"

The ghost, who said he was Gray Eagle, nodded. "I have been to the happy hunting grounds, but didn't like it. This rock is where my happiest days were passed. I have waited for a thousand years. But I shall be rewarded by dearest Laska, sister of the starts and of the night wind, my soul's mate."

As the writer left, the ghost said, "Come back one year from tonight and I will tell you the secret of the Rock."

The story may just have been the good imagination of a reporter who wanted to write about something he imagined.

Then Adelaide E. Sherry wrote a poem in 1900. "The Legend of Black Rock" told about an Indian maiden who leaped to her death from the summit after her husband, young chief Gray Eagle, had died in a battle along the Wabash River.

The other ghost story about Black Rock deals with this very woman. She watched her men leave from the high bluff. At the end of the day, they didn't return, so the word brought back to the camp was that Gray Eagle had been killed. That night the wife of Gray Eagle walked to the edge of the bluff and jumped to join her husband in death. To this day, some say on a damp night at the end of October you might see her reappear and once again jump off the cliff to join her husband.

Another writer who wrote about the site was Merton Knowles of nearby Williamsport. He set his novel *Rose of the Flowering Moon* at Black Rock.

There's also another story going around about Black Rock. One man said that when he was in grade school, he heard a story that some French soldiers had hidden a large sum of money there before an Indian battle. They were instructed not to tell a soul for fear it would be stolen. The money was to help support a fort near Lafayette called Ouiatenon, which was established in 1717.

Fort Ouiatenon was established in 1717. *Photo by W.C. Madden.*

The soldiers who hid the money died in the battle, but its location was revealed by one of the men to his wife in Boston in a letter. Due to the hostility in the area, the wife never came after the money. When her grandsons grew up, they came to see if the money was still there. When they saw the Black Rock, they knew the treasure was there. When they approached, a loud screech pierced their ears. Then a dark figure formed in front of them, and they ran away in fear, never to return.

The latest article about the ghost of Black Rock was written on June 28, 2009, by Bob Kriebel, who writes a column titled "Old Lafayette" for the *Lafayette Journal & Courier.*

hotel one Halloween night and was chased away by people who were holding a séance there.

The sound of gunfire has been heard coming from the old hotel, and strange clouds of fog have appeared in the area out of nowhere. People have been pushed from behind or grabbed by the ankles. Besides the eerie things going on there, parties making loud noise have disturbed neighbors in the nearby town of Kramer.

Today, the place is a little creepy. The walls—what's left of them—are marked with graffiti. Words like "Hell" or sayings like "Smile because it happened, not because it's over" are painted on the old walls. Debris and trash line the floors. All of the windows and doors are broken out. The ceiling has fallen through in a few areas. And you better watch your step or you could walk off a second-story floor. Trees have grown up around it and have camouflaged the place so much that it's barely visible from the road.

The springs seem to be gone, and the valuable mud has turned to dirt again. There are no signs of a golf course, tennis courts or any other evidence of a once thriving business—just paths made by vehicles, deer and people. Nature has taken back what man created.

Visit us at
www.historypress.net